Footwear

LA CALZATURA

Eugenia Girotti

CHRONICLE BOOKS

SAN FRANCISCO

First published in the United States of America by Chronicle Books in 1997.
Copyright © 1986 by BE-MA Editrice.

Printed in Hong Kong.

Library of Congress Cataloging-in-Publication Data:
Girotti, Eugenia.
 [Calzatura. English & Italian]
 Footwear = La calzatura / Eugenia Girotti.
 p. cm — {Bella cosa library)
 ISBN 0-8118-1469-6 (pb)
 1. Footwear—History I. Title II. Series
 GT2130.G5713 1996
 391'.413'09—dc20 96-13754
 CIP

Translation: Joe McClinton
Series design: Dana Shields, CKS Partners, Inc.
Design/Production: Robin Whiteside

Distributed in Canada by Raincoast Books
8680 Cambie Street
Vancouver, B.C. V6P 6M9

10 9 8 7 6 5 4 3 2 1

Chronicle Books
85 Second Street
San Francisco, California 94105

Web Site: www.chronbooks.com

Footwear—History and Traditions

Not just a means of locomotion, of protection, of communication, footwear is also an expression of custom and history. With a study of shoes, we can reconstruct historical periods and the social relationships that defined them. Our research has covered considerable historical and geographical ground; of the countless examples we examined, we have chosen only the most interesting, to create a historical survey of this major article of clothing. These beautiful photographs show construction techniques, unexpected oddities and details that not only conveyed social messages but also performed less obvious functions.

Down through a long line of metamorphoses, these images clearly show the evolution of footwear over time, and bear witness to the shoemaker's patient and inspired craftsmanship.

\mathcal{T}he use of footwear is documented as far back as the slate cosmetics tablet of the Pharaoh Narmer, of around 3000 B.C.: The carving shows the king followed by a servant carrying a pair of sandals. The image suggests that in ancient Egypt the sandal was a sign of power and rank—an idea borne out by the prisoners depicted on the inner surface of the soles of some sandals, symbolizing the Pharaohs' supremacy over those they had conquered. Slaves and the poor, of course, went barefoot.
Designed to protect the foot against the burning heat of the ground, early Egyptian sandals were plaited from plant fibers; later they were also made of leather.

Egitto

L'uso della calzatura è comprovato storicamente dalla celebre "tavola in ardesia per il trucco" del Faraone Narmer risalente a circa 3.000 anni a.c.; nella quale è raffigurato il re seguito da un servitore che porta in mano un paio di sandali. Da ciò ne deriva che, nell'antico Egitto, il sandalo era considerato simbolo di potere e di nobiltà. Tale concetto è rafforzato dalle raffigurazioni di prigionieri sul piano superiore della suola, presenti in alcuni sandali, che simboleggiavano la supremazia dei Faraoni sui vinti.
Ovviamente gli schiave e i meno abbienti andavano scalzi.
Il sandalo, atto a proteggere il piede dall'eccessivo calore del terreno, era costituito da intrecci di fibre vegetali.

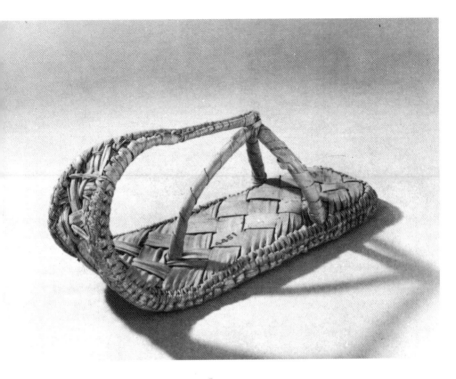

*E*gyptian sandal made of plant fiber (palm leaves). Note the characteristic triple thong structure that held the sandal on the foot. This sandal with a turned-up toe is believed to show Hittite influence, and may therefore date to around 1280 B.C. (British Museum)

Sandalo Egizio in fibre vegetali (foglie di palma). Caratteristica è la tripla struttura di lacci che permetteva di fissare il sandalo al piede. Riteniamo che il sandalo con la punta ricurva abbia subito l'influsso Ittita e quindi possa farsi risalire al 1280 a.c. circa. (British Museum)

From the arts of plaiting and braiding, the ancient Egyptians quickly progressed to weaving fibers as well as tanning hides for materials. Leather footwear held the most prestige. Leather sandals were worn by the Pharaoh, his family, dignitaries, and priests, and were decorated as befitted the wearer's status, with the soles dyed in different colors: white, green, red, or blue. Soles, shaped for the right and left feet, were commonly of tanned goat or sheep skin.

In a variety of materials, sandals were the most widely used footwear in Africa until relatively recent times, usually retaining the triangular lacing principle.

Evoluzione del Sandalo in Africa

Gli antichi Egizi dall'arte dell'intreccio passarono ben presto all'arte dell'ordire e poi e quello della concia.

Le calzature in cuoio, erano le più pregiate. Le suole, sagomate in destra e sinistra, erano ricavate, molto spesso, dalle pelli conciate delle capre e delle pecore.

Pur nella varietà dei materiali utilizzati, il sandalo rimane il tipo di calzatura più in uso, fino ad epoche recenti, mantenendo intatte le principali caratteristiche di chiusura "triangolare."

I modelli in cuoio erano destinati al Faraone, alla sua famiglia, ai dignitari e ai sacerdoti. Essi erano decorati in base al potere e il fondo aveva colori diversi: bianchi, verdi, rosi o blu.

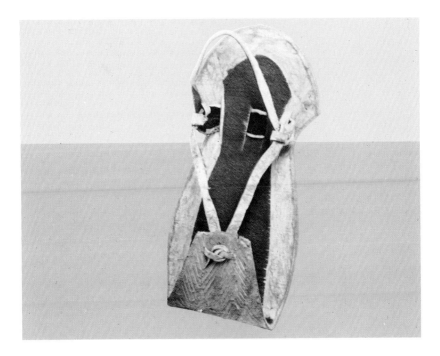

Sandal with turned-up toe from the Hausa culture of the southern Sahara. It is not known whether the turned-up toe was a status symbol or merely protection for the toenails, which were painted—particularly, but not only, by women. (Gift of Maria Ceretti-Bartolini, Vigevano Museum)

Sandalo a punta rialzata usato dagli "Haussa" nel Sud del Sahara. Non è certo se il sandalo a punta ricurva fosse usato come status symbol o per proteggere le unghie dei piedi che, in particolare le donne, coprivano di smalto. (Donzione Maria Ceretti-Bartolini - Museu di Vigevano)

\mathcal{S}omalian man's sandal. The sole, several centimeters wider than the foot, kept the wearer from sinking into the sand and protected against the scorching ground. (Private Collection: Madras/Valentine Shoe Manufacturers)

Sandalo somalo da uomo caratterizzato dalla suolo più larga, di alcuni centimetri, della pianta del piede, per evitare di affondare nell sabbia e quindi ripararsi dal terreno scottante. (Collezione Privata Madras - Calz. Valentine)

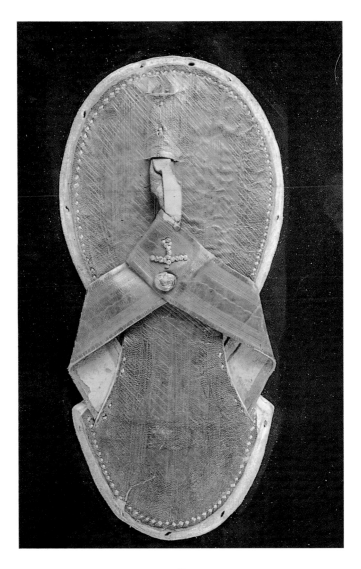

The Greeks took good care of their feet, adapting their footwear for every type of foot and activity. In the most ancient period women generally went barefoot, being confined to their duties in the home. As time went on, they too began to use footwear, which would flourish in Greece in both style and quality. Every type of footwear identified the wearer as a member of a specific social class.

Some examples of the numerous styles are the *krepis*, favored by soldiers because of its heavy leather; the common sandal, worn by the general population; women's wedding shoes, called *nymphidiai*; the *phaikas*, a handsome sandal reserved for priests; and the *kothornos* and *embates*, worn in performance respectively by tragic and comic actors. The kothornos (also known as the *cothurnus* or *buskin*) is our first recorded example of a clog or high-heeled shoe. Over six inches high, it raised the wearer above the crowd in both physical and social standing.

Grecia

I Greci avevano grande cura dei loro piedi al punto che conformarono la calzatura ad ogni tipo di piede e per tipo di attività.

Nella Grecia antica le donne generalmente andavano scalze perché relegate ai lavori domestici, con il passare del tempo si dette rilevanza anche alle loro calzature, tanto da prevedere le scarpe da nozze dette "Ninfidi."

In Grecia si ebbe un notevole sviluppo della produzione calzaturiera sia nelle fogge che nella qualità. Ogni tipo di calzatura serviva anche a distinguere l'appartenenza ad una determinata classe sociale.

Tra le numerosissime varietà si ricordano: la crepida, utilizzata particolarmente dai guerrieri per la pesantezza del cuoio; il sandalo, usato dal popolo; il fecaso, calzare elegante riservato ai sacerdoti; il coturno e gli embati, usati dagli attori sulla scena, rispettivamente per la tragedie e per le commedie.

Il Coturno è la prima testimonianza di zeppa o tacco, alta più di sei pollici che serviva per innalzare e rendere superiore chi lo portavo rispetto alla gente che lo circondava.

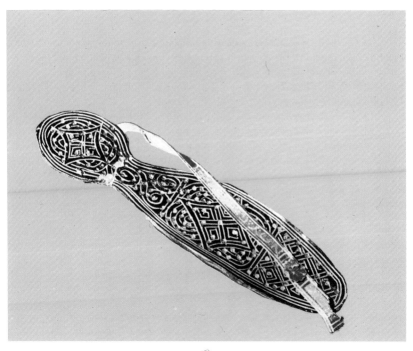

\mathcal{G}reek sandal of the Hellenistic era: a sole with elaborate, colored decorations and no upper, held on the foot by a strip of leather that is also decorated on the front. A style thought to have been particularly used by women because of the delicate ornamentation. (Bally Museum)

Sandalo Greco di età ellenistica — costituito da una suola con decorazioni elaborate e colorate, priva di tomaio e fissata al piede da una striscia di cuoio, anch'essa decorata, posta sulla parte anteriore. Particolarmente usata dalle donne anche per la raffinatezza dei disegni. (Museo Bally)

\mathcal{A}s Roman culture evolved and spread, Roman footwear diverged from the Greek models it had initially imitated, achieving a wide variety in both forms (as ostentatiously elegant as possible) and uses.

At first it was the officers of the Roman army who dictated fashion among the empire's various subjects.

Despite the sumptuary laws and price controls imposed by Diocletian in A.D. 301, footwear came in many styles and colors, each reflecting class distinctions. Shoemaking, known as the *ars sutrina*, flourished—so much so that a guild, the *collegium sutorum*, was established to guarantee that the trade would be carried on by students of the *officina sutoris*. The guild also divided shoemakers into two categories according to what they produced: *caligarii* for soldiers' boots, and *sandalarii* for civilian footwear.

Antica Roma

Le calzature dei romani, pur riprendendo da produzioni greche, con lo sviluppo della civiltà romana e la sua espansione, si distinsero per la molteplicità delle forme, come dimostrazione di eleganza, e per il loro uso.

In principio furono proprio gli ufficiale dell'esercito romano a dettare la moda fra i popoli dei vari Paesi.

Nonostante le leggi suntuarie e il calmiere imposto da Diocleziano nel 301 a.c., si ebbero numerosi tipi di calzature le cui fogge e colori riflettevano una distinzione di classe.

L'artigianato della calzatura detto "Ars Sutrina" fu molto fiorente, tanto da costruire una corporazione "Collegium Sutorum" che grantiva la continuita del mestiere attraverso gli allieri della "officina sutoris" e, nel contempo suddivideva i calzolai in due categorie a seconda della produzione: "Caligarii," per le calzature dei soldate, e "Sandalarii" per le calzature dei civili.

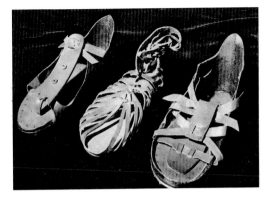

Variants of Roman *caligae*. These sturdy, thick-soled, heavy leather sandals had an upper that reached the instep, with a lattice of strips of softer leather tied around the shins or held against the bridge of the foot by a tongue. Caligae were worn by soldiers up to the rank of centurion, and came in several types: *speculatoria* (for scouts), *equestris* (for horsemen), *clavata* (with iron nails protruding underneath for fighting on rugged ground), as well as *senatorum* (worn by senators, quite different and far more elegant than the military version). (Bally Museum)

Varianto di caligae romane. Sono robuste calzature di cuoio con suola spessa e con tomaio che arriva al collo del piede, composto di un intreccio di strisce in pelle conciata legata alla tibia o trattenute sul dorso da una lingula. Usata dai soldati fino al grado di centurione. Si hanno diversi tipi di caliga: speculatoria (per esploratori), equestris (per cavalieri), clavata (con chiodi di ferro sporgenti per combattere su terreni scoscesi), senatorum (per i senatori, ma molto diversa e piè raffinata di quella militare). (Museo Bally)

*T*he advent of Christianity coincided with a general relinquishment of all that smacked of superfluity and decoration. It was not mere chance that in art Jesus, the Apostles, and the male saints were shown wearing simple shoes called *soleae*, while the Virgin, female saints, and women in general wore the more cultivated *calcei*. The foot was a symbol both of chastity and of spiritual weakness; only loose women wore sandals.

At the start of the Byzantine period, the symbols of Christianity became suffused with an oriental taste for luxury and fascination with form. Footwear was elegant in appearance and ineffable in color. Ecclesiastical footwear did not escape this influence. The Emperor Constantine is said to have presented a pair of embroidered purple shoes to Pope Sylvester, who had baptized him.

L'Era Cristiana

L'avvento del cristianesimo coincise con una riduzione di ogni elemento superfluo e decorativo, non a caso Gusù, gli Apostoli e i Santi venivano raffigurati con semplici, soleae, mentre la Madonna, le Sante, le donne in genere calzavano calcei raffinati perché il piede era simbolo di castitàe di celestiale debolezza; solo le donne di facil costumi calzavano i sandali. Con l'inizio dell'epoca bizantina, il fasto orientale e il culto della forma si fusero con i simbolismi del cristianesimo e le calzature assunsero un aspetto più raffinato e dai colori celestiali. Anche le calzature ecclesiali furono influenzate da questa "moda." Si narra che l'Imperatore Costantino regalò al Papa Silvestro, che l'aveva battezzato, un paio di scarpe ricamate, color porpora.

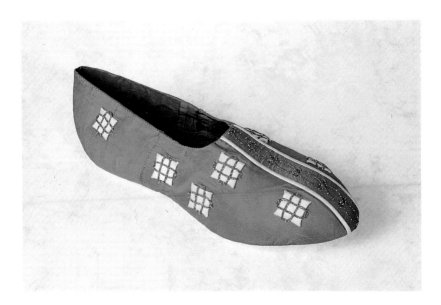

\mathcal{R}econstruction of one of the slippers of
Saint Sylvester (fourth century A.D.), who reigned
as Pope Sylvester I from 314 to 335. He wore
these slippers at the Council of Nicaea in 325.
Note the painstaking embroidery. The sturdy
leather sole is the same color as the appliqué
work. (Vigevano Museum)

*Ricostruzione delle pantofole di San Silvestro (IV
sec. d.c.). San Silvestro fu Papa col nome di
"Silvestro I" dal 314 al 335 d.c.
Queste calzature furono usate dal Papa Silvestro I
nel 325 d.c., durante il concilio di Nizza. Si noti l'ac-
curatezza della lavorazione del ricamo, suola in
cuoio dello stresso colore delle applicazioni e dei
riporti. (Museo Vigevano)*

The Byzantine period saw a considerable artistic and cultural revival. A spirit of religious exaltation pervaded; faith was transformed into visual symbol so that participation in the divine could be represented to the senses. Color acquired a religious symbolism that played a role in all works of art and even in clothing. Though the sandal predominated at first, the closed shoe and the slipper took center stage from the fourth century A.D. on.

Bisanzio

Nel periodo bizantino si ebbe un particolare risveglio artistico-culturale.

Vi fu una esaltazione religiosa e il mito venne trasformato in simbolo al fine di rappresentare la partecipazione al divino. Anche il colore fu assunto come simbolo religioso trasfuso in tutte le opere d'arte e anche dell'abbigliamento.

L'arte bizantina, comunque, fu un intreccio di elaborazione in funzione del pensiero religioso, delle tradizioni locali, dei costumi. Se nei primi albori della calzatura predominò il sandalo a partire dal IV sec. d.c. il ruolo di protagonista venne assunto dalla scarpa chiusa e dalla pantofola.

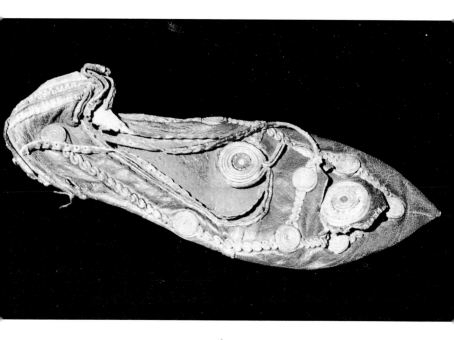

\mathcal{B}yzantine shoe of the sixth century A.D. It
has a heavy leather sole and a red-purple soft
leather upper, with gold embroidery and appliqués.
The colors are typical of Byzantine art and its
Christian religious influence. (Bally Museum)

*Calzatura bizantina del VI sec. d.c. Caratterizzata
dalla suola in cuoio e dal tomaio in pelle di colore
rosso porpora con una lavorazione di ricamo e appli-
cazioni in color oro.
I colori sono tipici dell'arte bizantina con influenza
religioso-cristiana. (Museo Bally)*

With the fall of the Western Roman Empire and the barbarian invasions, crafts-manship declined. Most common people went barefoot or wore wooden clogs; clerics were required to wear sandals. Among the most sought-after gifts in this era was a pair of shoes. Despite the crisis, women pursued elegance by any means available.

In the High Middle Ages, fashion revived and took a turn toward bizarre, complicated styles. Shoes acquired roles in a variety of rituals. It was during this period that pointed-toed shoes called *poulaines* or *crakows* were born, becoming popular throughout Europe and even beyond. Pointed toes began to shrink considerably by the end of the 1300s.

Medioevo

Con la caduta dell'Impero Romano e le invasioni barbariche si ebbe una diminuzione dell'attività del settore artigianale.

La maggior parte dei cittadini andavano scalzi o portavano zoccoli di legno.

Il regalo più ambito in quell'epoca era ricevere un paio di calzature. Solo gli ecclesiastici avevano l'obbligo di calzare i sandali. Malgrado la crisi, le donne facevano il possibile per essere eleganti.

La scarpa divenne simbolo di numerosi rituali. Nell'alto Medioevo ci fu una ripresa nel costume dell'abbigliamento che si orientò verso mode bizzarre e complicate. Fu in questo periodo che nacque la calzatura a punta e si propagò in tuti i Paesi Europei ed Extra Europei. Questa calzatura fu detta alla "poulaine." Verso la fine del 1300 le punte diminuirono considerevolmente.

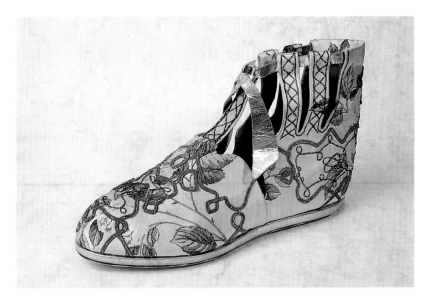

\mathcal{S}hoe of the Emperor Charlemagne, ninth century. Reconstruction. Charlemagne wore this shoe at his coronation in A.D. 800. Of the type called a *calceus*, it was reserved for official ceremonies and was closed at the ankle by laces, with variable amounts of fine decoration. Such shoes were so costly that people included them in their wills. (Vigevano Museum)

Scarpa dell'Imperatore Carlo Magno sec. IX.
Riproduzione. Tale scarpa fu calzata da Carlo Magno in
occasione della incoronazione avvenuta nell'800 d.c.
Questo tipo di calzatura che veniva indossata solo nelle
cerimonie ufficiali era detta "Calceo" e consisteva in una
scarpa chiusa alla caviglia da lacci in pelle più o meno
finemente lavorati. Il costo di tali scarpe era molto elevato
e perciò venivano lasciate in eredità. (Museo Vigevano)

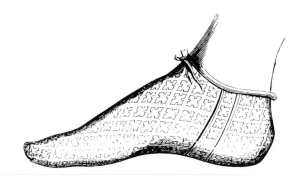

Shoe of Philip of France, twelfth century. A delicately worked calceus closed at the ankle by a little soft-leather or fabric lace. A simple, elongated line that anticipates the pointed toe of the poulaine shoe. (From *Footwear of the Brenta Riviera*)

Calzatura di Filippo di Francia, sec. XII. "Calceo" finemente lavorato, chiuso alla caviglia da un piccolo laccio in pelle o tessuto.
Linea semplice e sfilata che preannuncia la punta alla Poulaine o a becco. (Vol. La calzatura della Riviera del Brenta).

\mathcal{I}talian poulaine from 1430, worn especially by men. The pointed-toed style did not catch on in Italy as it did in England and Germany, or of course in France. The shoe shown here has a heavy leather sole and soft leather upper. The toe was often reinforced with a strip of wood to protect the point from dust and to identify individuals of highest status. The points were often stuffed with hair, wool, or moss. (Bally Museum)

Calzatura "à la Poulaine" italiana del 1430 utilizzata parti-colarmente dagli uomini e non dalle donne.
La moda della poulaines non attecchì molto in Italia, cosa che invece si ebbe in Inghilterra e in Germania dove si chiamò anche a "becco," nonché in Francia.
La calzatura raffigurata è in pelle con suola in cuoio, alla punta veniva spesso applicato un rinforzo costituito da un'asta di legno per proteggere le punte dalla polvere e per identificare le persone più altolocate. Molto spesso le punte erano imbottite con capelli, lana o muschio. (Museo Bally)

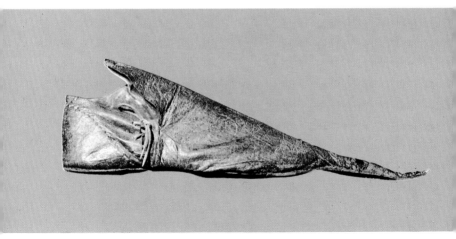

The Renaissance (at its height from the late fifteenth to the mid-sixteenth century) was a period of momentous events in Europe—political, spiritual, and socioeconomic. Cities flourished and a strong middle class arose.

Fashion reflected the changes. Long, pointed toes yielded to a broad-nosed style called the "duckbill" in England or *muso di bue* ("ox muzzle") in Italy. This was also the period of the "horned" shoe, with a wide toe stuffed out to the sides. Later on, the toe lost its excessive length, but still remained square. While men wore duckbill shoes, women preferred wood or cork clogs, called *pantofles,* of various heights, with less squared toes. Later came finely worked shoes of soft leather or fabric, with brocaded or other decorations.

Rinascimento

Il Rinascimento (fine secolo XV seconda metà secolo XVI) fu caratterizzata, in Europa, da grandi avvenimenti in campo politico, spirituale, socio-economico, che permisero un rifiorire delle città e la nascita di una forte borthesia.

Anche la moda ne fu influenzata e da punte lunghissime si passò ad una punta larga a "muso di bue."

In questo periodo furono presenti anche "le scarpe con le corna" la cui punta larga era imbottita lateralmente. In una fase successiva la punta perse la sua eccessiva lunghezza ma rimase squadrata. Mentre gli uomini portavano calzature a "muso di bue," le donne preferivano zoccoli in legno e di sughero con punte meno quadrate e di varie altezze. Per queste calzature fu coniato il nome di "pantofola." Seguirono scarpe finement lavorate in pelle o tessuto con decorazioni o in broccato.

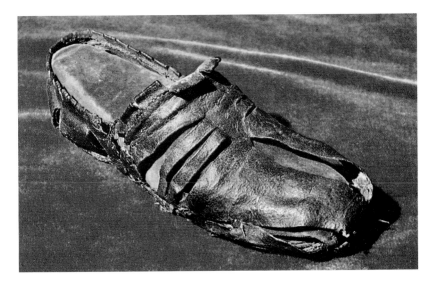

*R*enaissance man's shoe from Italy. Note the slashed upper. These shoes were popularly known as *tagliate a pezzi* ("cut to bits"). The slashes had two purposes: They let the feet breathe and also showed off the wearer's white or colored hose. (Bally Museum)

Scarpa italiana rinascimentale da uomo. Caratteristica da notare sono gli "spacchi" nell tomaia, nel linguaggio del popolo le calzature erano definite "tagliate a pezzi." La funzione degli spacchi era duplice: apportare aria ai piedi e far notare le calze bianche o colorate. (Museo Bally)

\mathcal{W}oman's pantofle of 1540. The toe is squared, but less so than in the duckbill style. The sole is cork, covered with soft leather, and the upper is of perforated soft leather. (Bally Museum)

Calzatura femminile a pantofola del 1540. Punta squadrata ma meno pronunciata di quella a "muso di bue." Suola in sughero, ricoperta in pelle, e tomaio in pelle con buchi. (Museo Bally)

\mathcal{A} pantofle that belonged to Beatrice d'Este Sforza (born in Ferrara, 1475, died in Milan, 1497). She was the daughter of Duke Ercole I of Ferrara and wife of the great Ludovico Sforza of Milan, called "Il Moro." A mule of tooled soft leather, with a heavy leather sole attached to a raised bottom. (Vigevano Museum)

Pantofola appartenuta a Beatrice d'Este Sforza (nata a Ferrara nel 1475 e morta a Milano nel 1497 — figlia del Duca di Ferrara. Ercole I, e sposa di Ledovico il Moro). Pantofola in pelle intarsiata con suola in cuoio applicata ad un fondo rialzato. (Museo Vigevano)

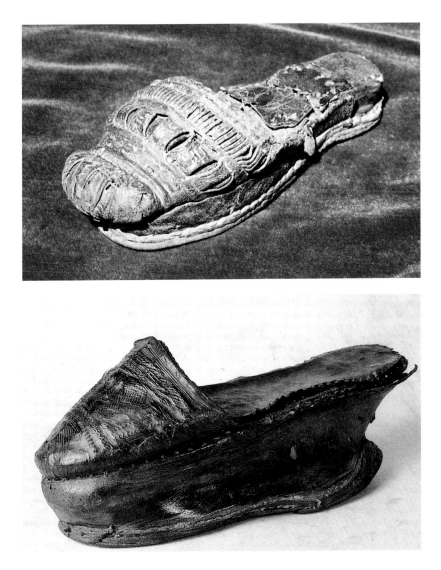

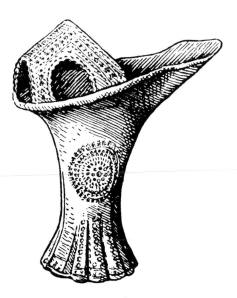

\mathcal{T}he platform-sole shape influenced the Venetian style called the *chopine*. This example, one of the first stilt-type shoes, is from the sixteenth century. The bottom was hollow, and might be of wood or cork—the latter being preferred for its light weight. To stay upright, the lady might use wooden rods as walking sticks. (From *Footwear of the Brenta Riviera*)

La forma a ponte ha influenzato le calzature veneziane dette "Chopine." Raffigurata, è una chopine veneziana del XVI sec., che costituisce una delle prime versioni a trampolo. Il fondo, cavo all'interno, può essere in legno o in sughero, materiale, questo, preferito per la leggerezza. Per sorreggersi, la signora a volte usava bacchettine di legno tipo bastoncino. (Vol. La Calzatura della Riviera del Brenta)

\mathcal{A} Spanish pantofle, a wooden clog with a soft leather upper nailed to the sole and reinforced with an arch of leather-covered wood across the bridge of the foot. It appears to be from the early Spanish Renaissance. (Private Collection: Rossetti Bros.)

"Pantofola"— zoccolo spagnolo in legno con tomaio in pelle fissato intorno alla suola da chiodi e rinforzato sopra il dorso del piede da un semicerchio in legno ricoperto in pelle. Sembra essere del primo rinascimento spagnolo. (Collezione Privata F.lli Rossetti)

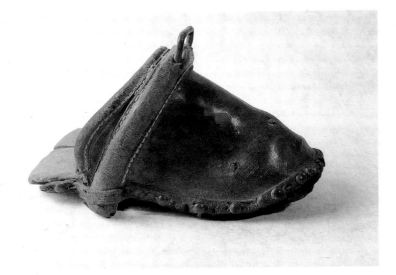

Venetian "stilt" clogs (51 cm high) of the sixteenth century. These are a vertiginously tall variant of the chopine. A mule top of leather or finely worked calfskin, sewn with waxed hemp thread, was attached to the wood or cork stilts. Sometimes the stilt was inlaid or covered with fine fabric or soft leather. These shoes were used when Venice had no pavements, so a lady would not get spattered with mud. They were so tall that she needed an attendant to hold her up. (Correr Museum)

Zoccoli veneziani di cuoio a trampolo (alt. cm. 51) del sec. XVI.
Sono una variante delle chopine veneziane, caratterizzate proprio dalla vertiginosa altezza. Sopra il trampolo di legno o di sughero venivano fissate saldamente calzature in cuoio o in pellame leggero finemente lavorato e cucito con filo di canapa incerata. A volte il trampolo veniva lavorato con intarsi o ricoperto di fine tessuto o pelle. Si usavano quando a Venezia non esistevano marciapiedi e quindi per evitare alla signora di infangarsi. Vista l'altezza del tacco la signora era sorretta da cameriere. (Museo Correr)

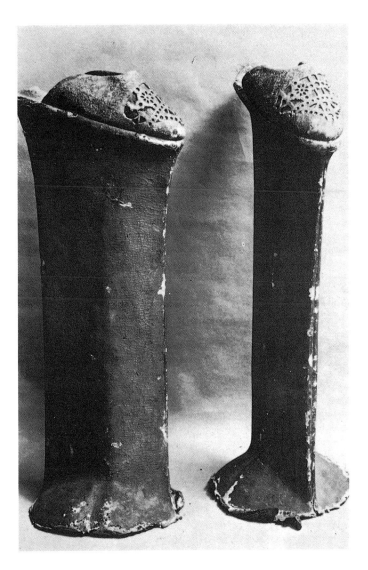

Another variant of the sixteenth-century clog, with a vamp strap of tooled heavy leather. As can easily be seen, it is raised on two sturdy pieces of carved wood. (Correr Museum)

Altra variante dello zoccolo-poggiapiedi del sec. XVI, con fascia di cuoio intarsiata. Come si può ben notare il ponte è costituito da due assi di legno molto robuste e modellate. (Museo Correr)

Venetian wooden clog inlaid with mother-of-pearl, sixteenth century. The fine mother-of-pearl decoration appears on both the sole and the stilts themselves. The vamp band of heavy leather, with rivets *à pois*, is edged with fabric that was generally the same color as the rest of the outfit. (Correr Museum)

Zoccolo veneziano di legno, intarsiato in madreperla, sec. XVI. Come si può notare la base del trampolo e i trampoli stessi sono finemente decorati in madreperla. La fascia trasversale in cuoio sormontata da bulloni a "formare pois" è rifinita in tessuto generalmente del colore dell'abito. (Museo Correr)

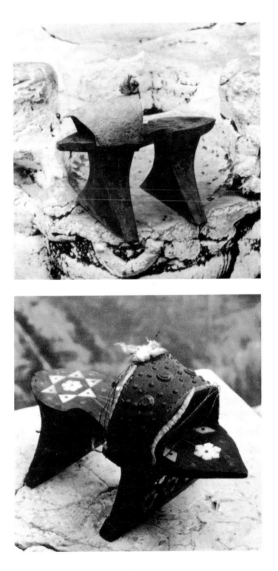

\mathscr{A} Venetian noblewoman's ivory-inlaid wooden clog in oriental style, sixteenth century. The strap that held it on the foot is made of leather covered with embroidered fabric with a variety of colors and insets. (Correr Museum)

Zoccolo veneziano di legno, intarsiato in avorio, di tipo orientale, sec. XVI. La fascia che serve per fissare il piede è in cuoio sormontato da tessuto intarsiato, ricamato e con vari colori.
Sicuramente usate da una nobile signora veneziana.
(Museo Correr)

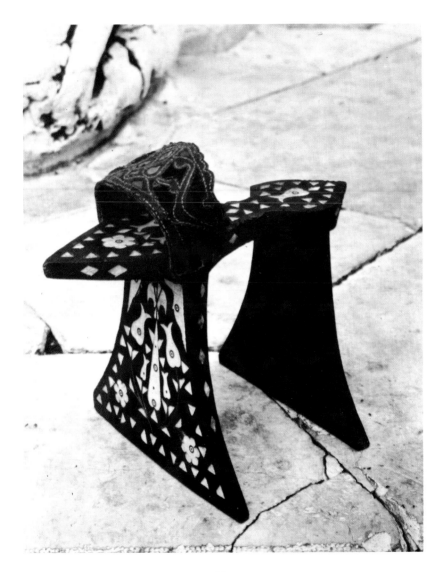

\mathcal{S}hoe from Lombardy, with gray and gold decoration, dating from the second half of the sixteenth century. A rare example of a man's shoe with an early tall heel, rather massive but not extremely high. The heel is a block of wood, covered with fabric and nailed to the leather sole. (Bally Museum)

Scarpa con decorazioni grigie e oro, risalente alla seconda metà del secolo XVI, proveniente dalla Lombardia. È un raro esemplare di calzatura maschile che mostra i primi tacchi piuttosto massicci, ma non eccessivamente alti. Come si può notare il tacco è un blocco di legno ricoperto in tessuto e attaccato alla suola in cuoio con chiodi. (Museo Bally)

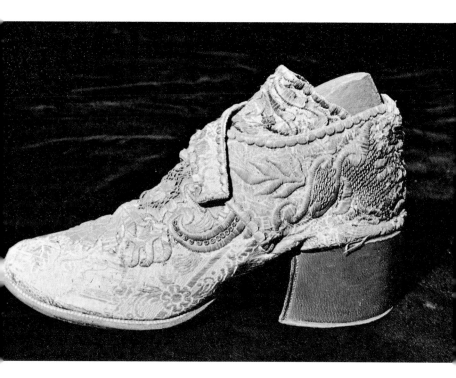

*I*n the first half of the century Italian styles show the influence of other European countries, such as Holland, France, and Spain. Italy seems to have lost its creative dynamism in this period, perhaps because of losing political independence. Only Venice maintained its creativity intact. The second half of the century saw the advent of the Baroque, not just in art but in fashion. In this era the heel, with all its variants, came into its own, making footwear more graceful. Shoes were of silk and brocade, and dancing shoes came back into style.

The real champion of the age was the top boot. Boots underwent many changes: first narrow and knee-high, then wide with elaborate cuffs, and finally, in the second half of the century, rigid and sturdy, with straps.

Seicento

In questo secolo distinguiamo varie fogge con influenze di Paesi Occidentali quali Olanda, Francia, Spagna (I^a metà sec. XVII). L'Italia in questo periodo sembra avere perso ogni slancio creativo forse proprio per la perduta indipendenza.

Solo Venezia mantiene intatta la sua creativita. Nella seconda metà del sec. XVII si ha l'avvento del "Barocco" che investe non solo l'arte ma anche l'abbigliamento. Nel seicento si ha l'affermazione del tacco nelle sue varianti, quasi a conferire snellezza alla calzatura. Le Scarpe sono di seta e di·broccato. Il trionfo vero lo ha, però, lo stilvalone.

Lo stivale durante questo secolo subisce molte trasformazioni: dapprima stretto e alto fino al ginocchio, poi largo con risvolti nella parte alta e, nella seconda metà del seicento, rigido, robusto e con fasce.

Le scarpette da ballo ritornano ad assere di moda.

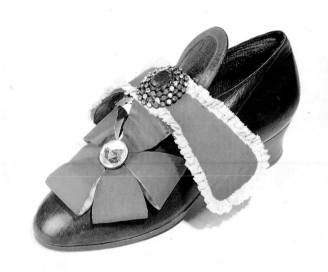

Reconstruction of a shoe from the reign of
Louis XIV, the Sun King (1643–1715).
Showing the typical French ostentation of the day,
this shoe of soft black leather is adorned with
bows, lace, and brooches. Note the characteristic
seventeenth-century heel, which was generally red,
in conjunction with the black upper. (Vigevano
Museum)

*Riproduzione di una calzatura risalente al periodo di
Luigi XIV, "il re sole" (1661–1715).
Caratterizzata dal tipico sfarzo francese dell'epoca,
questa calzatura in pelle nera è impreziosita da appli-
cazioni di fiocchi, merletti e spille.
Notare la caratteristica del tacco del seicento che
generalmente è rosso in abbinamento al tomaio nero.
(Museo Vigevano)*

Typical dancing shoe of the seventeenth century, of fine beige silk decorated with pleated bows that are attached with something akin to a buckle. (Private Collection: Rossimoda)

Tipica calzatura da ballo del secolo XVII, realizzata in finne seta beige ed impreziosita da fiocchi arricciati e fermati da una applicazione a mo' di fibbia. (Collezione Privata Rossimoda)

Man's shoe of the seventeenth century. The tapered toe reflects the influence of the medieval poulaine. The buckle and bow date it to the early part of the century, when these fastenings first begin to appear. (Private Collection: Rossimoda)

Calzatura maschile del sec. XVII. La punta slanciata sicuramente influenzata da quella "a becco." Denota l'appartenenza agli inizi del seicento proprio la fibbia e il fiocco, chiusura che inizia ad intravvedersi in questo secolo. (Collezione Privata Rossimoda)

Closed "Molière" style shoe from late in the century. The heel is beginning to rise higher. The shoe has a sleek, bronzed, black leather upper, with a high vertical tongue fastened by a cross-strap with a button. A walking shoe, with an elongated, truncated toe. (Vigevano Museum)

Scarpa chiusa alla Molière. Databile fine 1600. Il tacco inizia ad assumere una maggiore altezza. Tomaio sfilato in pelle nera, bronzata, linguetta verticale alta e fermata da un'altra orizzontale con bottone. È una scarpa da passeggio con punta allungata e mozza. (Museo Vigevano)

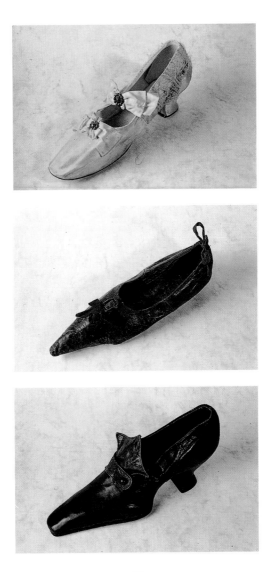

\mathcal{R}econstruction of a woman's shoe of the seventeenth century. Note the two-toned coloring, red and black with gilt decoration, and the high tongue rising beyond the ankle. The heel and counter are high; the wearer's heel rests against the broad portion of the rear part of the sole and slants forward.

This is the start of the late Baroque heel, and already shows a Rococo influence. (Vigevano Museum)

Riproduzione di una calzatura femminile del sec. XVII. Da notare il bicolore nero-rosso con interventi dorati e l'alta linguetta che supera la caviglia.

Calcagno alto e tacco che poggia sull'ampiezza posteriore della suola per poi inclinarsi.

Inizia la forma del tacco del tardo barocco con influsso Rococò. (Museo Vigevano)

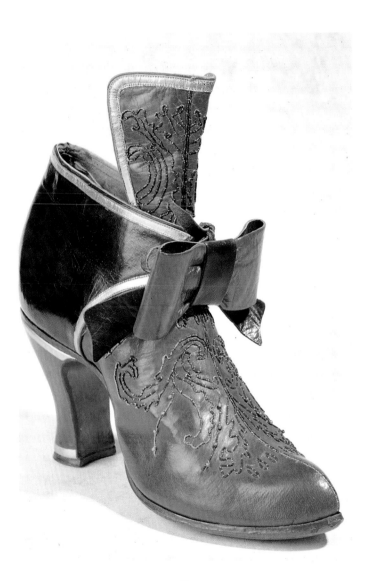

\mathcal{L}ate Baroque woman's high-heeled shoe, Paris, 1680. The heel is getting higher in imitation of the Sun King, Louis XIV, who perhaps raised the heels of his shoes in order to make the most of his short stature. Note the details of the heel, which has a base smaller than the part that rests against the very steep rear part of the sole. (Bally Museum)

Scarpa tardo barocca da donna con tallone alto — Parigi 1680. Il tacco diventa più alto, alla moda di Luigi XIV, il Re Sole, che forse per imporsi maggiormente, data la sua bassa statura, sentì la necessità di far aumentare i tacchi. Notare la particolarità del tacco che ha la base più piccola rispetto alla parte che appoggia al calcagno che, tra l'altro, risulta essere molto inclinata. (Museo Bally)

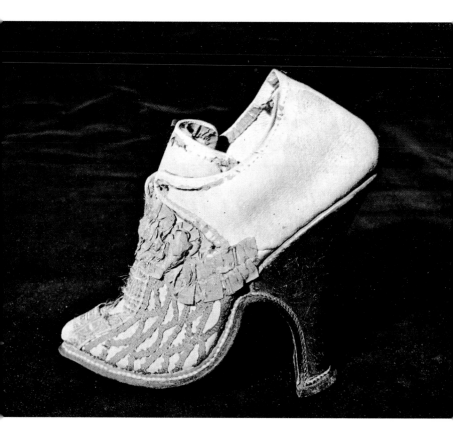

The eighteenth century was an age of extravagant appetite for pleasure and high living among the rich, particularly in France after the death of the Sun King, and in Venice, which abandoned its political, military, and commercial ambitions after 1718. The Rococo held sway until the second half of the century, and fashion ranged from refinement to affectation. Venice embraced all aspects of the Rococo, but with a twist of its own. After 1770, the Enlightenment inspired a revival of classical art, and the Neoclassical period saw more practical, less affected styles.

Il Rococò e il Settecento Veneziano

Il XVIII secolo è caratterizzato dalla voglia di vivere e di godere, in moda particolare ciò viene vissuto dalla Francia, dopo la morte del Re Sole, e da Venezia che, dopo il 1718, rinuncia alle imprese politico-belliche-commerciali.

Il Rococò imperò fino alla seconda metà del '700 e la moda fu caratterizzata dalla raffinatezza e dalla leziosità. Venezia assunse tutti gli aspetti del Rococò, ma gli diede una tratto particolare. Dopo il 1770, ispirandosi all'illuminismo si ebbe un ritorno all'arte classica. Con il periodo "neoclassico" si ebbe, una moda più pratica e meno leziosa.

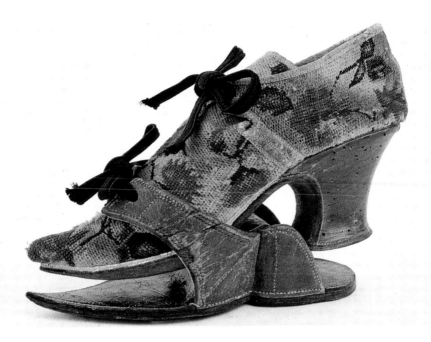

This type of shoe with an accompanying patten, or overshoe, became popular around the turn from the seventeenth to the eighteenth century. The patten, put on before going outdoors, was an accessory to keep the shoe clean. The illustration shows a Venetian brocade shoe with a protective patten. (Private Collection: Rossimoda)

Verso la fine del sec. XVII e l'inizio del sec. XVIII si affermò questa caratteristica calzatura con pattino. Il pattino veniva messo prima di uscire di casa, per non sporcarsi le scarpe, e lo si toglieva quando si rientrava.
Il pattino rappresentava un completamento per l'igiene della calzatura. L'illustrazione rappresenta una calzatura Veneziana in broccato protetta da pattino. (Collezione Privata Rossimoda)

\mathcal{R}eproduction of a "mule" slipper or pantofle for a young Venetian woman of the eighteenth century. (Vigevano Museum)

Riproduzione di una "Pantofola" femminile di una giovane veneziana sec. XVIII. (Museo Vigevano)

\mathcal{E}legant eighteenth-century pump of kid, lamé, and red satin. The upper is decorated with pearls, paste gems, and gold-colored embroidery. Note the red heel.
Although Louis XV had introduced white footwear to match his hose, red heels survived until around 1760. (Private Collection: Rossimoda)

Calzatura elegante del XVIII sec. realizzata in capretto, lamè e raso rosso.
Tomaio decorato con perle, strass e ricami color oro.
Da notare il particolare del tacco: il colore rosso.
Infatti, nonostante Luigi XV avesse introdotto calzature bianche per uniformarle alle calze, "i tacchi rossi" permasero fino a circa il 1760.
(Collezione Privata Rossimoda)

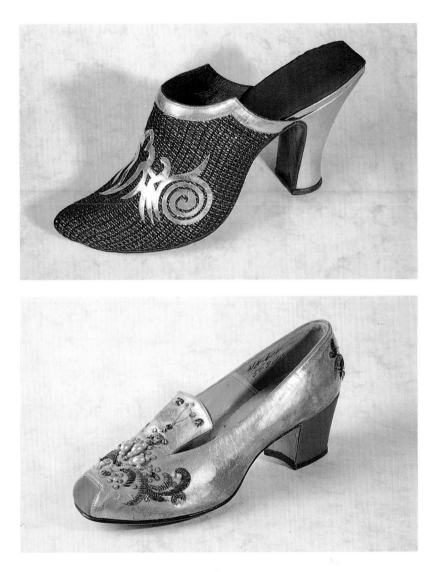

Venetian shoe from the eighteenth century, in an elongated "slipper" form, of delicate beige silk adorned with bows. The outstanding features of this shoe are its light color, typical of the Rococo, and its sharply tapered, underslung heel. (Private Collection: Rossimoda)

Calzatura veneziana del 1700 a forma scivolata "pantofola" realizzata in delicata seta beige ed ornata da fiocchi. La caratteristica di questa calzatura è data dal colore chiaro che predomina nello stile Rococò e dal tacco molto sfilato e rientrante. (Collezione Privata Rossimoda)

Venetian lady's bedroom slipper from around 1750. The slipper has a low wooden heel and a heavy leather sole. The sole is lined with a fine velvet, and like the upper is padded and embroidered in contrasting shades from light green to yellow. (Private Collection: Rossimoda)

Pantofole da camera di una veneziana del 1750 circa. La pantofola ha un tacco basso in legno e suola in cuoio. La parte superiore della suola, quella visibile, è foderata di un fine velluto, come il tomaio, imbottito e ricamato in colore contrastante e nuances dal verde chiaro al giallo. (Collezione Privata Rossimoda)

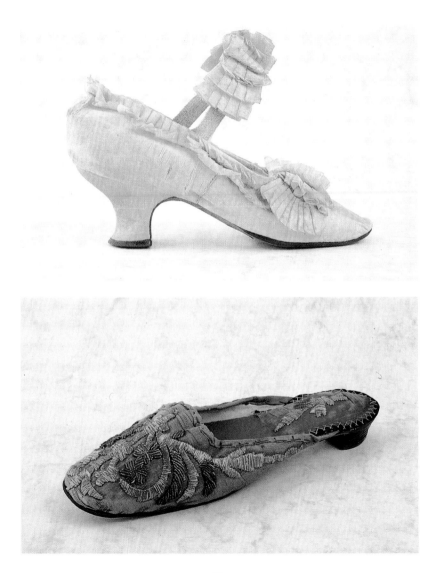

\mathcal{W}ide-topped half-boot of embroidered leather with low heels, eighteenth century. Leather strips are inset in the upper so the wearer can pull the boot on without stretching the structural leather out of shape. (Correr Museum)

Stivaletto a tromba in cuoio ricamato del sec. XVIII. Tacco basso ed inserimenti di cuoio a "fettuccia" in pelle nella parte superiore dello stivale per permettere di calzarlo senza stirare il cuoio. (Museo Correr)

\mathcal{V}enetian lady's dancing pump, second half of the eighteenth century. Made of delicate dark velvet in keeping with the taste of the age. Gold-colored embroidery and edging, and a daisy pattern in small ivory-colored beads. (Private Collection: Rossimoda)

Calzatura da ballo di una veneziana della II metà del XVIII secolo.
Realizzata in prezioso velluto scuro come vuole la moda del secondo settecento. Ricami e passamanerie color oro, disegno di margherita realizzato con perline color avorio. (Collezione Privata Rossimoda)

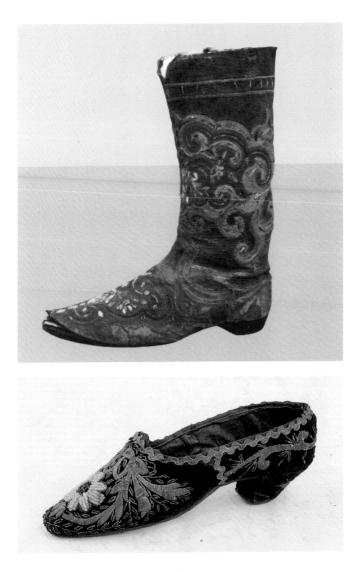

An unusual example in white leather with brown toe and detailing, high heel, and closure around the ankle with a button. The under-sole at the toe and heel, another type of patten, is typical of the period. This shoe is signed by the maker, with the year: "Panagin Cochinato e Comp.i 1782." (Correr Museum)

Curioso esemplare di calzatura in cuoio bianco con profili e punta marroni.
Tallone elevato, chiusura alla caviglia con bottoncino. Caratteristica è la sottosuola applicata alla pianta e al tacco elevao, detta "pattino." Questa calzatura indica la fabbrica e l'anno di costruzione; è infatti firmata "Panagin Cochinato e Comp.i" 1782. (Museo Correr)

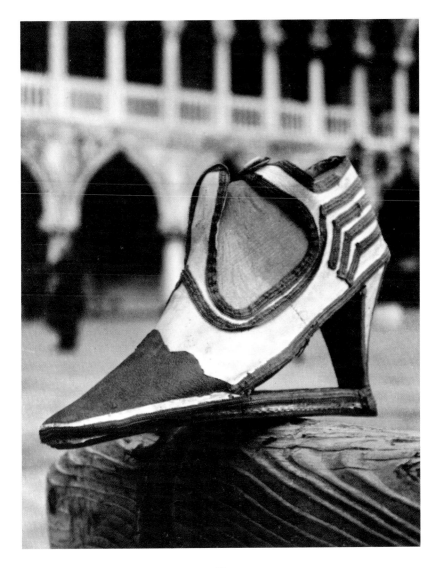

Women's shoe presumed to be from the eighteenth century. It may be a walking shoe. Kid, with a silk ruche on the vane. (Private Collection: Rossimoda)

Calzatura da signora del XVIII secola circa.
Si ritiene possa essere una calzatura da passeggio.
Realizzata in pelle di capretto con una ruche di seta
nella parte anteriore. (Collezione Privata Rossimoda)

Venetian dancing shoe of the eighteenth century. The linear form and the working of the striped fabric probably date it to the end of the century. (Private Collection: Madras/Valentine Shoe Manufacturers)

Scarpa da ballo veneziana del sec. XVIII. Questa
calzatura é caratterizzata da una linearità di forma e
dalla particolare lavorazione a righe del tessuto che
potrebbe far individuare la sua costruzione verso la
fine del settecento. (Collezione Privata Madras - Calz.
Valentine)

Woman's shoe of the eighteenth century, with a metal buckle in keeping with the French style of the era (Louis XVI). The heel is covered with the same soft leather as the upper, with clearly defined stitching. (Vigevano Museum)

Calzatura da signora del secolo XVIII, caratterizzata
dall'applicazione della fibbia in metallo come voleva
la moda francese di quell'epoca (Luigi XVI). Tacco
ricoperto dalla stessa pelle del tomaio con cuciture
evidenti. (Museo Vigevano)

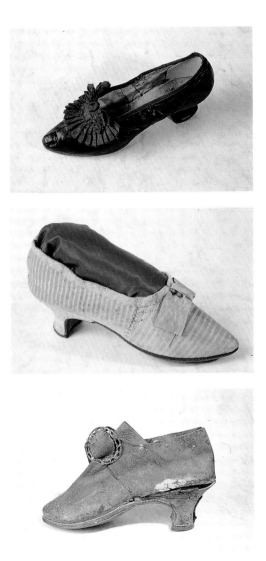

\mathscr{A} man's variant of the preceding shoe. The differences are the buckle—in this case squarer, heavier, and centered—and the heel, which is neither underslung nor as high as on the women's shoe. The shoe fits more snugly around the ankle. (Vigevano Museum)

Variante della precedente calzatura, ma utilizzata dall'uomo. Le differenze sono date dalla fibbia che in questa calzatura è più squadrata, massiccia e centrale, ma particolarmente dal tacco che non ha la rientranza e l'altezza tipica del tacco da donna. La scarpa è più accollata verso la caviglia. (Museo Vigevano)

\mathscr{R}econstruction of a Venetian noblewoman's slipper from the eighteenth century. As can be seen, not all slippers were open at the back. Since it has almost no heel, this shoe is thought to date from the end of the century. (Vigevano Museum)

Riproduzione di una pantofola di una nobile Veneziana del 1700. Come si può notare non tutte le pantofole erano caratterizzate dalla apertura posteriore. Si ritiene possa ricondursi alla fine del secolo XVIII per la quasi totale mancanza del tacco. (Museo Vigevano)

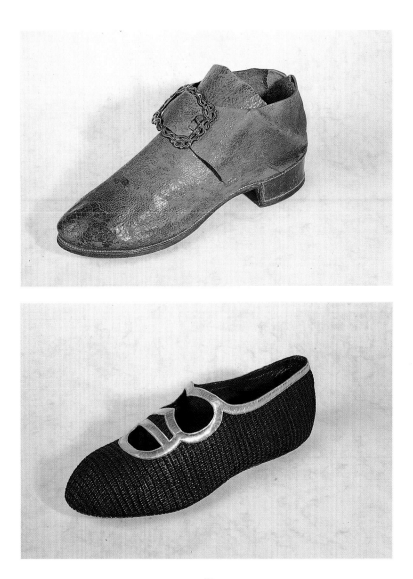

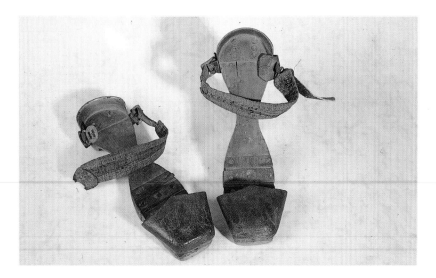

\mathcal{C}log from the late eighteenth century, possibly 1785–1800 (Neoclassical/ Directoire period). It was used by the common folk, especially peasants. There is no reliable documentation for this wooden shoe, which flexes on a hinge covered with a thin piece of iron or bronze. It is reminiscent of the "Tyrrhenian clog" of the Roman period. (Vigevano Museum)

Calzatura di fine secolo XVIII, forse referentesi al periodo 1785–1800 (neoclassico-direttorio) e usata probabilmente dal popolo e particolarmente dai contadini. Non si hanno riferimenti certi su questa calzatura in legno resa flessibile da cerniere rivestite in lamine di ferro o di bronzo.
Ricordo il famoso "zoccolo tirrenico" di epoca romana. (Museo Vigevano)

\mathcal{E}ighteenth-century boot. These were called "strong" boots because of their toughness and height. This example is a stiff ox-hide tube with a high cuff. (Private Collection: Rossimoda)

Stivali del secolo XVIII. Furono chiamati stivali "Forti" per la loro durezza e altezza. La figuera rappresenta uno stivale consistente in un duro tubo con risvolto alto, in materiale di pelle di bue. (Collezione Privata Rossimoda) ➢

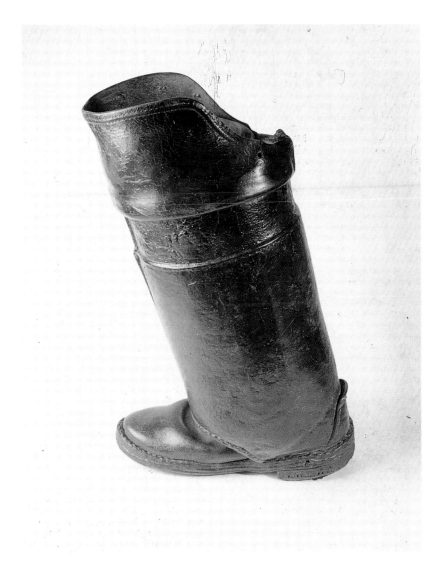

Reconstruction of a French slipper of 1790–1795, from the time of the Revolution. The upper is finely embroidered with a lady's head. (Bally Museum)

Riproduzione della pantofola francese del periodo della rivoluzione, ricamata finemente sul tomaio con testa didonna (1790–1795). (Museo Bally)

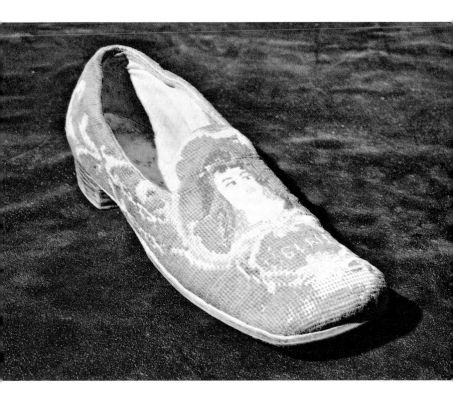

There is no doubt that European shoe production has been influenced throughout history by Eastern styles and customs. This was particularly true in the fourteenth to seventeenth centuries.

The sandal, clog, poulaine, Venetian chopine, patten, stilt shoe, and even the little Rococo shoe are hardly more than Western transmutations of Eastern models.

To give a panorama of some of the Asian and African shoes that influenced Western fashions, a few rare examples follow. For many there is no available historical documentation.

L'Influenza Orientale e Africana

Non vi è dubbio che tutte le produzioni di calzature europees siano state influenzate dalle fogge e costumi orientali.

Particolarmente ciò è avvenuto nei secoli XIV, XV, XVI e XVII.

Il sandalo, lo zoccolo, la calzatura a becco, la chopine veneziana, il pattino, la scarpa a trampolo, ed anche la piccola calzatura rococò, non sono altro che proposte di calzature orientali trasformate dalla cultura occidentale.

Al fine di offrire una panoramica di calzature orientali e africane che hanno influenzato la moda occidentale si presentano, qui di seguito, alcuni rari esemplari, di cui, molto spesso, non si hanno riferimenti storici.

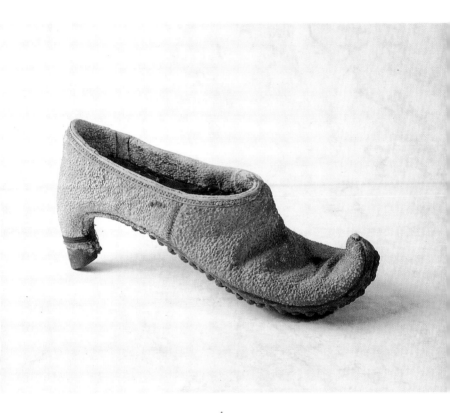

A Persian shoe from the sixteenth century, with turned-up toe and an iron heel. The upper is nailed to the sole. (Private Collection: Rossetti Bros.)

Calzatura della Persia risalente al XVI secolo con punta a "becco" e tacco in ferro.
Tomaio fissato alla suola per mezzo di chiodi. Forse appartenente ad un "Ragià." (Collezione Privata F.lli Rossetti)

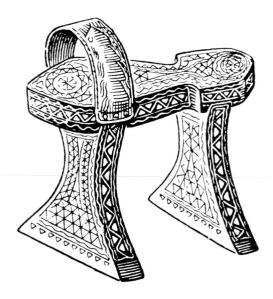

A Syrian *kubkab*, decorated in silver and mother-of-pearl. A shoe for bathing or for the street, but particularly for the baths, where it protected the foot from the hot floor. Very similar to medieval European clogs. (from *Footwear of the Brenta Riviera*)

Kubkab siriaca, decorata in argento e madreperla. Scarpa da bagno o da strada ma particolarmente usata nei bagni a causa del suolo surriscaldato. Corrispondente agli zoccoli europei medioevali. (Vol. La Calzatura della Riviera del Brenta)

\mathcal{P}ersian wooden slipper with turned-up, pointed toe. Note that the sole is lined with quilted soft leather, while the underside is covered with a stiff, tougher hide. (Private Collection: Rossetti Bros.)

Pantofola iraniana in legno con punta a "becco" rialzata. Da notare il rivestimento della suola superiore con pelle imbottita. Mentre la parte inferiore è ricoperta da cuoio rigido. (Collezione Privata F.lli Rossetti)

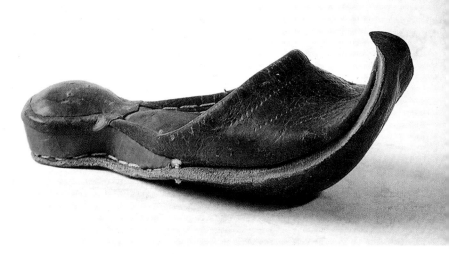

Woman's dancing sandal. It is made of a single block of wood, with an arched shank that results in a "heel" effect. The sole is carved with geometric designs. The lace was presumably used to hold the clog on the foot. (Vigevano Museum)

Sandalo femminile da ballo. Realizzato da un unico blocco in legno e lavorato a ponte per dare l'effeto "tacco." La base d'appoggio è intarsiata a disegni geometrici. Il laccio serviva molto probabilmente per fissare il piede allo zoccolo. (Museo Vigevano)

Arab woman's riding slipper or *babbuccia* with a built-in stirrup (1800). (Vigevano Museum)

Babbuccia araba femminile da sella (1800) con staffa incorporata. (Museo Vigevano)

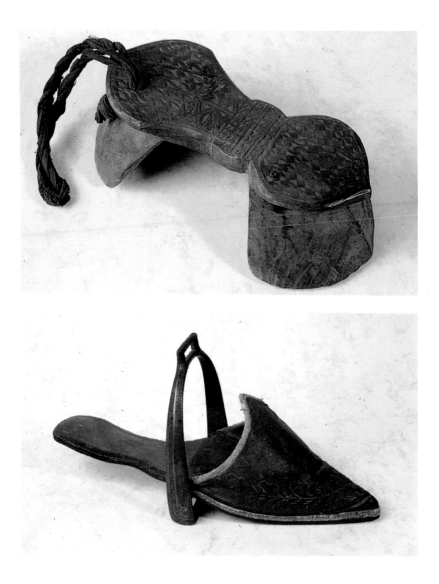

Tunisian clog of wood covered with small mother-of-pearl plates and held onto the foot with an intricately decorated band nailed to the sides. (Private Collection: Rossetti Bros.)

Pattino tunisino realizzato in legno ricoperto da scaglie di madreperla; fissato al piede da una fascia finemente decorata e inchiodata ai lati. (Collezione Privata F.lli Rossetti)

Asian clog of carved, inlaid fig-tree wood. (Private Collection: Rossetti Bros.)

Zoccoletto orientale in legno di fico intarsiato. (Collezione Privata F.lli Rossetti)

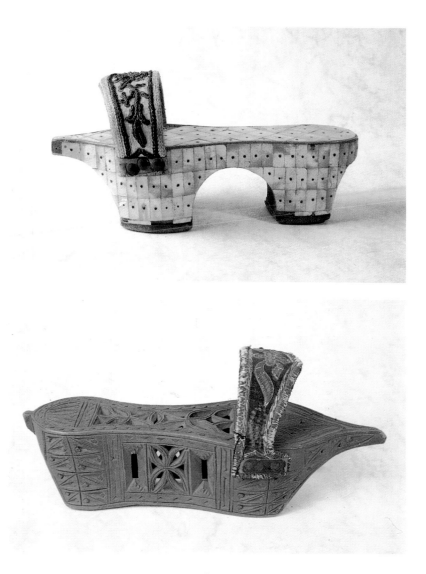

\mathcal{T}unisian sandal with ivory and mosaic inlay.
(Private Collection: Rossetti Bros.)

Sandalo tunisino con intarsi in avorio e mosaico.
(Collezione Privata F.lli Rossetti)

\mathcal{I}ndian bathing clog of wood, for use by a
princess or noblewoman. (Private Collection:
Rossetti Bros.)

Calzature indiane da bagno in legno utilizzate da
principesse o nobili donne. (Collezione Privata F.lli
Rossetti)

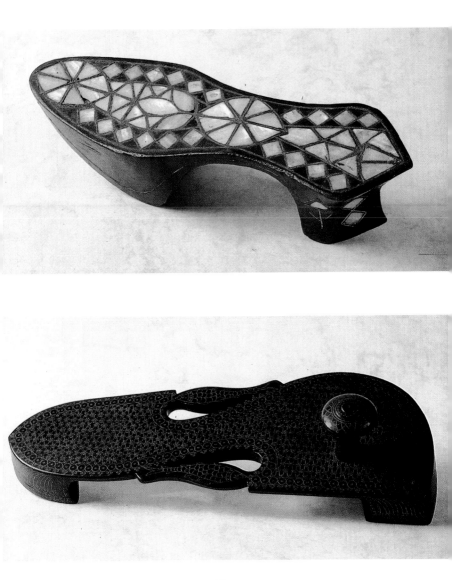

Japanese shoe for amusement, with a spring attached to the underside of the colored wooden sole. The upper is of interlaced leather straps. (Private Collection: Rossetti Bros.)

Scarpa giapponese da gioco con molla applicata nella parte inferiore della suola costituita da legno colorato; tomaio in strisce di cuoio intrecciate. (Collezione Privata F.lli Rossetti)

An Asian woman's slipper. Note the very delicate embroidery, particularly on the inner surface of the sole, which was intended to show as the wearer walked. (Vigevano Museum)

Babbuccia femminile orientale. Notare il ricamo finissimo su tutta la calzatura e particolarmente sulla parte superiore della suola da mostrare durante il cammino. (Museo Vigevano)

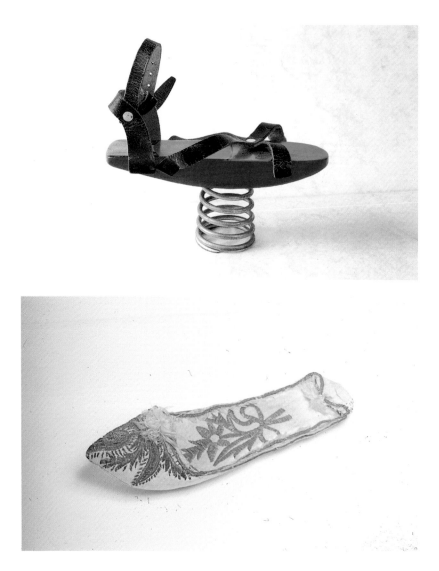

\mathcal{K}orean wooden clog with a plaited cord upper. The bandlike upper passes from one side to the other through cuts in the clog. (Private Collection: Rossetti Bros.)

Zoccolo, coreano di legno, il cui tomaio è realizzato in corda intrecciata. Il tomaio a forma di fascia passa da una parte all'altra attraverso tagli effettuati nello zoccolo. (Collezione Privata F.lli Rossetti)

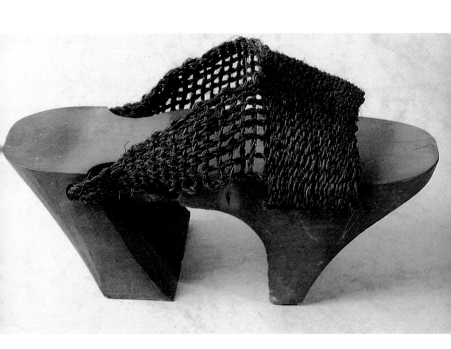

\mathcal{A} woman's ceremonial shoe for a bound foot. Especially used in Northern China. (Private Collection: Madras/Valentine Shoe Manufacturers)

Scarpa femminile da cerimonia per "rattrappimento" del piede a fini estetici.
Particolarmente in uso nella Cina Settentrionale.
(Collezione Privata Madras)

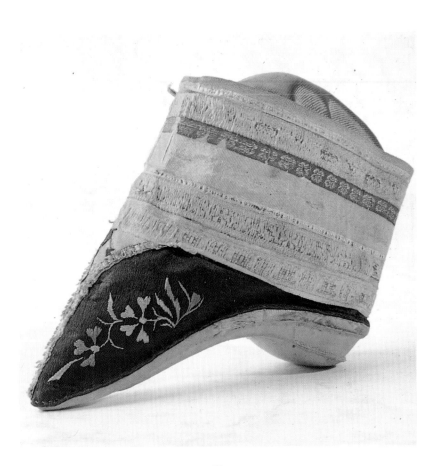

\mathcal{C}hinese slipper from the Ming dynasty. A thick sole of cork or wood with a leather sole attached; upper with insets of fine embroidery. Particularly used by dignitaries. (Private Collection: Rossetti Bros.)

Pantofola cinese della dinastia MING. Fondo alto in supghero o in legno con applicazione di suola in cuoio. Tomaio finemente ricamato ad intarsio. Particolarmente utilizzata dai dignitari. (Collezione Privata F.lli Rossetti)

\mathcal{J}apanese "Känguruh" shoe. Note the odd spoonlike shape, with a tapered back to which a little heel is attached. (Private Collection: Rossetti Bros.)

Scarpa giapponese "Känguruh." Da notare la partico-lare forma a cucchiaio, sfilata nella parte posteriore sul cui fondo è applicato un piccolo tacco. (Collezione Privata F.lli Rossetti)

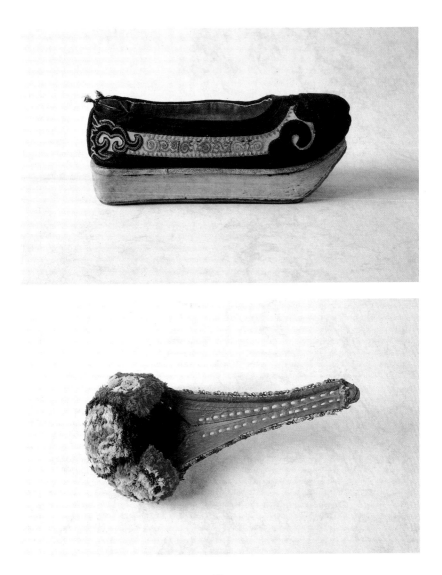

\mathcal{J}apanese shoe of finely embroidered fabric. The base is balanced on an intersole, which was usually of painted wood or cork in a gondola or boat shape. The reason for this shape is unknown, but it may have been adopted to make the wearer seem taller while at the same time making the shoe more graceful and slender, as well as to protect the delicate upper from the dust and mud of the street. (Private Collection: Madras/Valentine Shoe Manufacturers)

Calzatura giapponese, in tessuto finemente ricamato. La base di appoggio è bilanciata da un'intersuola, generalmente in legno o sughero dipinto a forma di "gondola o barca."
Non é noto il motivo della particolare forma, adottato forse per innalzare la persona e nel contempo offrire alla calzatura una linea meno goffa e più slanciata, oltre che salvaguardare la "preziosa" tomaia dalla polvere e dal fango delle strade. (Collezione Privata Madras - Calz. Valentine)

\mathcal{A}n *opanka*, a Croat-Dalmatian woman's shoe of the nineteenth century. The shoe is made of pressed leather with a double lace and embroidery. Note the interesting turned-up toe covered with a brightly colored pompom. (Vigevano Museum)

Calzatura "Opanka" femminile croato-dalmata del XIX secolo. La calzatura è cuoio stampato con coppia allacciature e ricami.
Notare l'interessante punta ripiegata e coperta da un coloratissimo "pompon." (Museo Vigevano)

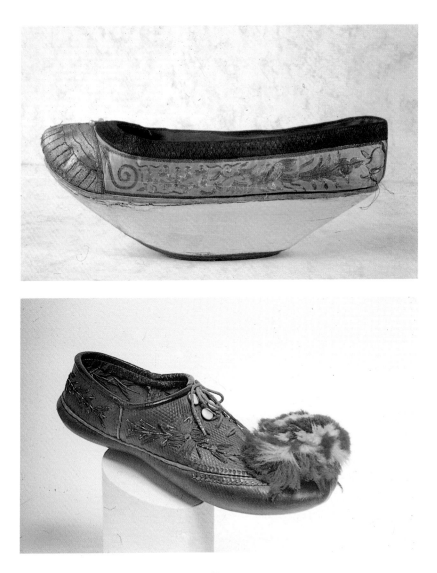

*C*hinese children's boot of red fabric decorated with floral patterns. (Private Collection: Rossetti Bros.)

Stivaletto cinese da bambino in tessuto rosso decorato a motivi floreali. (Collezione Privata F.lli Rossetti)

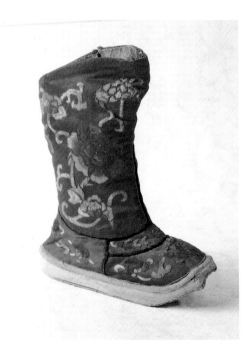

*T*raditional Tunisian boot. Note the unusual
lacing, with soft leather laces ending in tassels.
(Private Collection: Rossetti Bros.)

Tradizionali stivali tunisini. Notare la particolare
allacciatura a stringhe in pelle terminanti con fiocchi.
(Collezione Privata F.lli Rossetti)

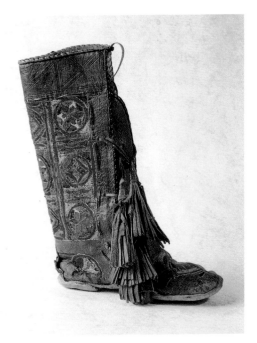

\mathcal{A}fter the French Revolution and the Directoire period, the early decades of the 1800s saw a revival of classicism. Footwear, sometimes of patent leather, was low-heeled and ornamented with knots and straps. This is the style of the Restoration and Louis Philippe (1815–1848).

From 1848 to 1870, with the Second Empire, the Romantic movement was slowly over-laid by various other influences, giving rise to the New Rococo with low pumps and light boots laced very similarly to modern styles.

After 1870 the "Liberty" style was born in England—and came to be known on the con-tinent as *Art Nouveau.*

Ottocento — Il Romanticismo

Dopo la rivoluzione e il direttorio si ha un rinato amore per il classicismo. I primi decenni dell'800 furono caratterizzati da una certa ripresa, ma le calzature, a volte in vernice, erano piatte e ornate da nodi e cinturini.

È questo lo stile restaurazione e Luigi Filippo (1815–1848).

Dal 1848–1870 con il secondo Impero; il movimento romantico venne lentamente sopraffat-to da varie ispirazioni e si dette vita al "Nuovo-Rococò," caratterizzato da scarpette basse e stivaletti con allacciature molto simili alle forme più moderne. Dal 1870 in poi nacque lo stile "Liberty" in Inghilterra che nel continente prese il nome di "Art Nouveau."

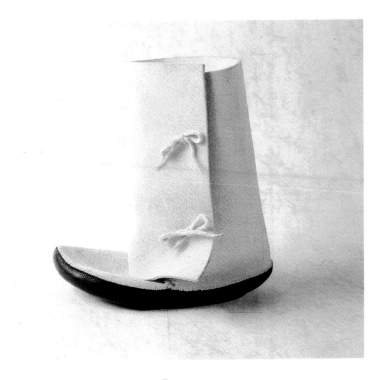

*C*hildren's shoe in black and white. The date of this shoe is not documented, but it is thought to be from around 1800. (Private Collection: Rossetti Bros.)

Stivale da bambino in bianco e nero. Di questo stivale non si conosce il periodo storico di riferimento, ma si ritiene possa collocarsi alla fine del '700 e inizi '800. (Collezione Privata F.lli Rossetti)

A woman's half-boot, or ankle-boot, made of delicate fabric; early nineteenth century. Note the lacing above the instep, typical of the era. (Private Collection: Rossimoda)

Stivaletto, più modernamente chiamato "tronchetto," femminile dell'inizio del secolo XIX, in fine tessuto, caratterizzato dalla presenza di lacci nella chiusura laterale interna, tipica di quell'epoca. (Collezione Private Rossimoda)

French-Swiss woman's pump from around 1820 (Restoration style). (Bally Museum)

Pantofola femminile franco-svizzera del 1820 (Stile restaurazione). (Museo Bally)

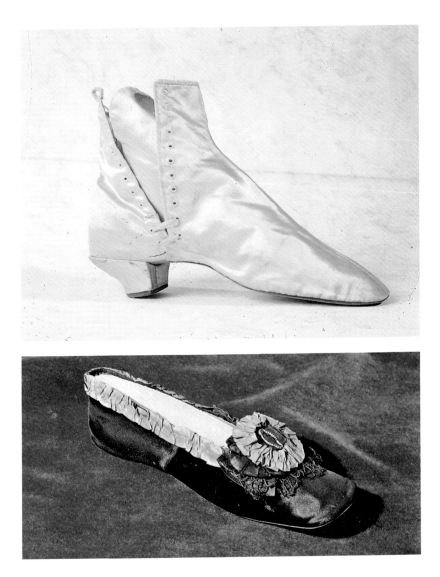

\mathcal{B}eautifully embroidered slipper from the age of Louis Philippe (1830). This shoe shows the influence of the Directoire period, as can clearly be seen by comparing it with the example on page 61. (Private Collection: Rossetti Bros.)

Pantofola del periodo di Luigi Filippo, finemente ricamata (1830). Tale calzatura risente l'influsso del periodo del direttorio come si può ben confrontare con la calzatura di pag. 61 della presente monografia. (Collezione Privata F.lli Rossetti)

\mathcal{W}oman's theater shoe, nineteenth century. This slipper, delicately decorated with green silk, has a pointed *babbuccia* or babouche shape. Note the timid return of the heel at the beginning of the century. (Vigevano Museum)

Calzatura femminile da teatro sec. XIX.
La calzatura è finemente lavorata in tessuto di seta verde ed ha una forma a babbuccia.
Da notare il timido ritorno del tacco all'inizio di questo secolo. (Museo Vigevano)

\mathcal{E}cclesiastical shoe of red fabric with a leather sole, intended for a priest (nineteenth century). (Private Collection: Rossimoda)

Calzatura ecclesiastica di tessuto rosso e suola in cuoio destinata ad un sacerdote (sec. XIX). (Collezione Privata Rossimoda)

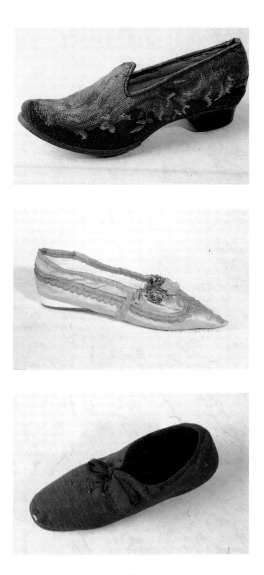

Two-tone woman's boot; the top is of leather openwork. From the first decades of the nineteenth century. The beginnings of the New Rococo style are evident. (Vigevano Museum)

Stivaletto femminile, bicolore con parte superiore in pelle intarsiata, risalente ai primi decenni del secolo XIX. Si inizia a intravvedere la nascita del "nuovo rococò." (Museo Vigevano)

Woman's lace-up boot from the early nineteenth century, with insets in different shades of leather. (Vigevano Museum)

Stivaletto femminile dell'inizio del secolo XIX con allacciatura di stringhe e intarsi in pelle di nuances differenti. (Museo Vigevano)

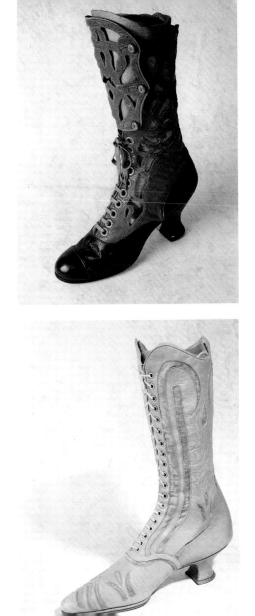

\mathcal{L}ady's babouche-type slipper from the first half of the nineteenth century, made of finest velvet embroidered with colored soft leather. (Private Collection: Rossimoda)

Babbuccia da Signora della prima metà secolo XIX, realizzata in finissimo velluto e arricchita da decorazioni a ricamo di pelle colorata. (Collezione Privata Rossimoda)

\mathcal{W}oman's walking shoe with straps that rise from the center and button at the sides. Rococo-type "spool" heel. (Vigevano Museum)

Calzatura femminile da passeggio con cinturini che, partendo dal centro, terminano lateralmente con un bottone. Tacco a "rocchetto" tipo rococò. (Museo Vigevano)

\mathcal{B}oy's low boots of canvas, laced above the instep (1853). (Vigevano Museum)

Polacchetto in canvas stringato lateralmente, destinato ad un ragazzo (1853). (Museo Vigevano)

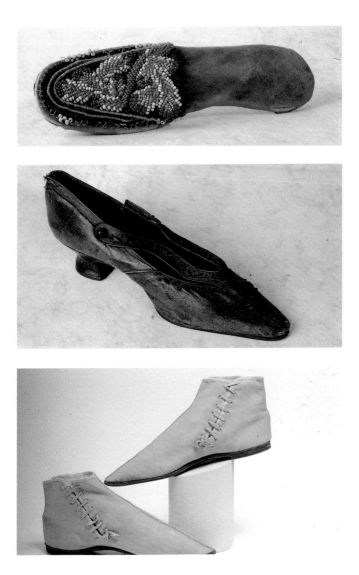

Woman's ankle-boot, nineteenth century: a half-boot that came up to the calf, for walking. Note the cord laces. (Vigevano Museum)

Tronchetto da donna del XIX secolo: stivaletto la cui altezza arriva al polpaccio, usato per passeggiate. Da notare l'utilizzo del cordoncino per l'allacciatura. (Museo Vigevano)

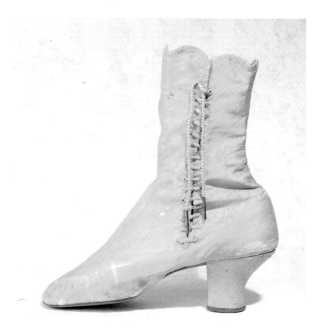

\mathcal{A} woman's high-buttoned half-boot, for walking. Nineteenth century. (Vigevano Museum)

Versione di stivaletto femminile da passeggio con chiusura di piccoli bottoncini sec. XIX. (Museo Vigevano)

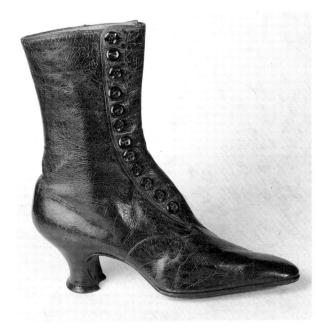

Man's walking boot with hard leather heel, soft leather upper, and an elastic insert, rising from the ankle to the calf, that expanded to fit the leg. (Vigevano Museum)

Stivaletto maschile da passeggio con tacco in cuoio, tomaio in pelle ed inserimento di elastico nella parte alta del gambale che va dalla caviglia al polpaccio allargandosi in conformità alla gamba. (Museo Vigevano)

"Evening" version of the men's boot above. Elastic above the instep, but the shoe material is fabric (satin) and only the toe is reinforced with soft leather. (Vigevano Museum)

Versione "sera" del precedente stivaletto maschile. Presenza di elastico nella parte interna, ma il materiale utilizzato è il tessuto (raso) con punta rinforzata in pelle. (Museo Vigevano)

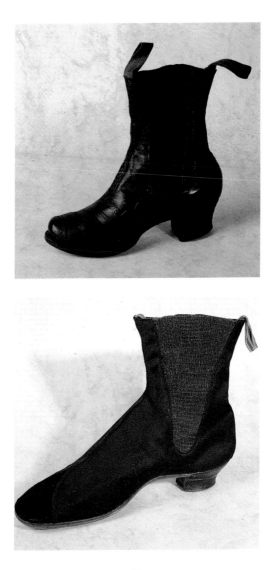

Two versions of women's shoes that fit snugly around the ankle, dating from the early nineteenth century. Characteristic features for this period: The first shows the laced "Richelieu" design, with a patent leather toe; in the second photo, the shoe is not laced but has elastic inserts and is embroidered with pearls. (Vigevano Museum)

Due versioni di calzature femminili accollate, risalenti alla prima metà dell'800. Caratteristica di questo periodo è: nella prima calzatura il modello "Richelieu" stringato, con punta in vernice, nella seconda foto la calzatura non è stringata ma presenta inserti di elastico e ricami in perle. (Museo Vigevano)

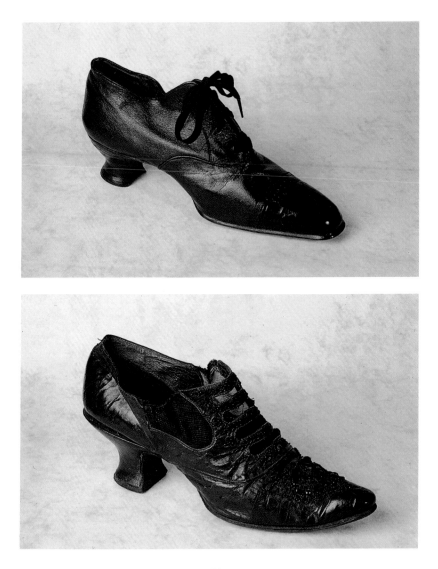

\mathcal{C}hild's riding half-boot from 1896: The fine leather is stiff but accordion-folded to make it more flexible. (Vigevano Museum)

Stivaletto da bambino alla "Scuderia" del 1896 — realizzato in pelle rigida ma accartocciata a mò di fisarmonica per dare maggiore flessibilità. (Museo Vigevano)

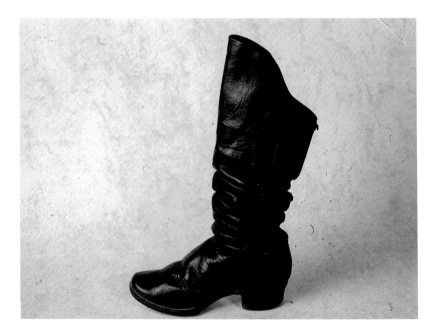

\mathcal{G}erman woman's ankle-boot with a marked Art Nouveau influence, from the turn of the century. (Bally Museum)

Polacchetto femminile tedesco con notevoli influssi Art-Nouveau fine '800 primi '900. (Museo Bally)

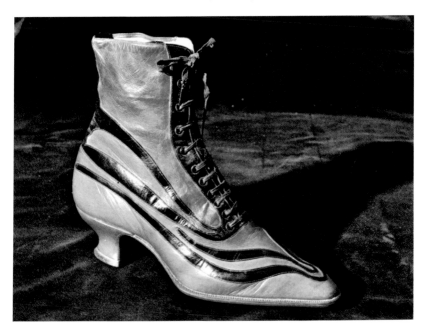

\mathcal{S}hoe that belonged to Achille Cardinal Ratti (born in Desio, 1857; died in Rome, 1939) while he was in residence as Archbishop of Milan. (Vigevano Museum)

Calzature appartunute a Sua Eminenza Cardinale Achille Ratti (nato a Desio nel 1857 e morto a Roma nel 1939) durante la Sua permanenza a Milano come Arcivescovo. (Museo Vigevano)

\mathcal{S}hoe that belonged to Achille Ratti, worn during his papacy as Pius XI (1922–1939). (Vigevano Museum)

Calzature appartenute a Sua Eminenza Achille Ratti e calzate durante il suo Papato (1922–1939) con il nome di Papa Pio XI. (Museo Vigevano)

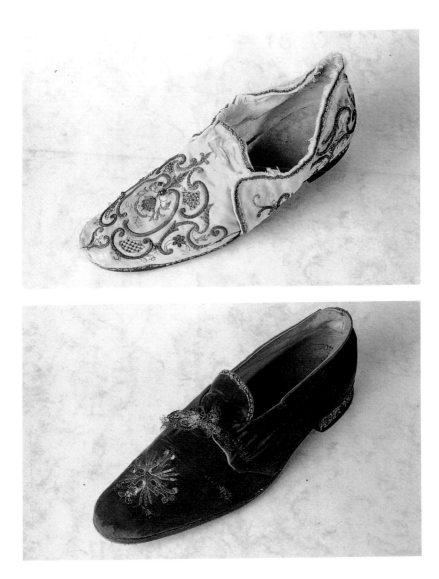

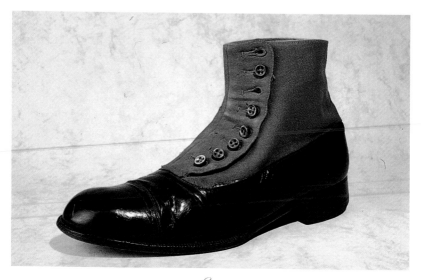

\mathcal{S}hoe that belonged to Benito Mussolini, an ankle boot of black calfskin with built-in gray kid spat and side buttons. (Vigevano Museum)

Calzatura appartenuta a Benito Mussolini, realizzata a forma di polacchetto con pelle di vitello nero con ghette incorporate di pelle in capretto grigio. Allacciatura laterale esterna a piccoli bottoni. (Museo Vigevano)

\mathcal{L}ady's theater boot from the early twentieth century, showing Art Nouveau inspiration with soft laminated leather insets and fabric laces. (Vigevano Museum)

Stivali da teatro per Signora inizi XX secolo, di ispirazione "Art Nouveau" caratterizzati da intarsi in pelle laminata e allacciatura a stringhe in tessuto. (Museo Vigevano) ➤

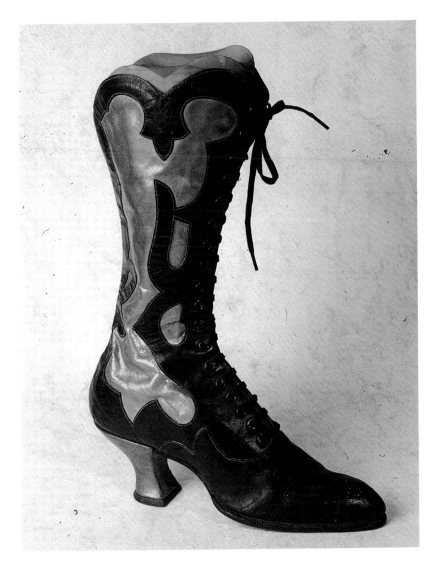

\mathcal{W}oman's sandal from the "self-sufficiency" period (1935), but still using leather. An evolution of the beach sandal that has been around since Roman times. Upper of colored soft leather strips and sole of heavy leather with small, sectioned tubes attached, in the same colors as the upper, mostly of wood. (Vigevano Museum)

Sandalo da donna del periodo autarchico (1935).
È una evoluzione del sandalo stile "riviera" presente anche al tempo dei romani.
Tomaio a strisce di pelle colorata.
Fondo in cuoio con applicazione di piccoli tubicini di forma circolare dello stresso colore del tomaio, generalmente in legno. (Museo Vigevano)

\mathcal{W}oman's "self-sufficiency" sandal (1942), with a heel and intersole of clear synthetic resin. (Vigevano Museum)

Sandalo femminile autarchico (1942) realizzato con tacco e intersuola in resina sintetica trasparente. (Museo Vigevano)

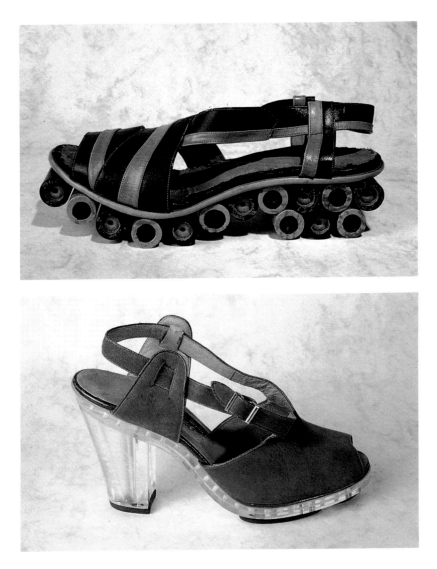

\mathcal{W}oman's sandal from the "self-sufficiency" period (1938). A creation of Ferragamo, who was known as the "shoemaker to the stars," this shoe was inspired by American musicals. The upper is of shaped and padded straps of gilt kid, with a scalloped toe. The sole and heel are layers of cork covered with chamois in various colors. (Private Collection: Ferragamo)

Sandalo femminile del periodo autarchico (1938) creato da Ferragamo soprannominato "il calzolaio delle dive" ed ispiratosi per questa calzatura ai musicals americani. Le particolarità di questo sandalo sono costituite dalla tomaia formata da lacci imbottiti, in capretto dorato, profilati con punto a smerlo e l'intersuola e tacco a strati di sughero ricoperti di camoscio in vari colori. (Collezione Privata Ferragamo)

\mathcal{W}artime shortages brought in the use of alternatives to leather, and in 1947 Ferragamo produced this "invisible shoe" with an upper of transparent nylon filaments and an F-shaped wedge sole covered with soft gilt leather. This shoe was created as an ideal complement to outfits by Dior. (Private Collection: Ferragamo)

Le difficoltà del periodo bellico portano all'impiego di materiali alternativi alla pelle e nel 1947 Ferragamo realizza questo modello di "scarpa invisibile" con tomaia in filo di nylon trasparente e intersuola a zeppa di legno, rivestita in pelle dorata, con la forma a "F." Questa scarpa fu creata come complemento ideale degli abiti di Dior. (Collezione Privata Ferragamo)

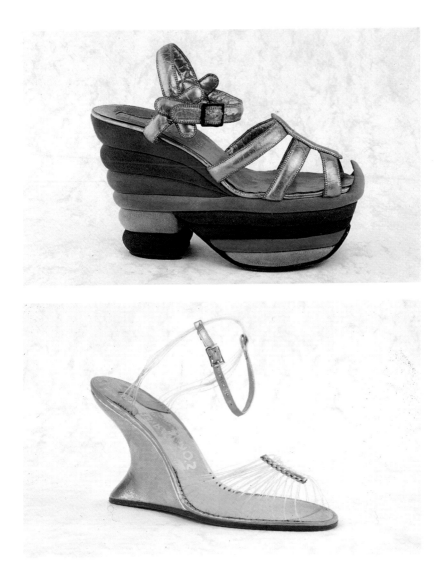

\mathcal{A} shoe created by Ferragamo after the war, around 1947–1950, a period when the "shoemaker to the stars" joined forces with couturière Elsa Schiaparelli to launch the Italian look.
This model, presented as part of the new style, brings back the heel and banishes the wedge; the upper, snug around the ankle and lacing almost all the way up with braided cords, is of black antelope skin, with an unusual "rhinoceros" toe. (Private Collection: Ferragamo)

Calzatura del 1947–50 creata da Ferragamo sul finire della guerra, periodo in cui il "calzolaio delle dive" lancia, insieme ad Elsa Schiapparelli che disegna abiti, L'italian look.
Questo modello, proposta della nuova moda della calzatura, ripropone il tacco e bandisce la zeppa, la tomaia accollata e chiusa, fin quasi la caviglia, da cordoncini intrecciati, è realizzata in antilope nero e in una forma inconsueta dalla punta tip "rinoceronte."
(Collezione Privata Ferragamo)

\mathcal{A} delicately crafted woman's pump with Art
Deco–inspired patterns. The light-colored soft
leather upper has a lace overlay (mid-twentieth
century). (Private Collection: Rossimoda)

*Calzatura femminile finemente lavorata di ispirazione
art-decò nei disegni.*
*Lavorazione in pizzo che ricopre il tomaio in pelle
chiara (metà sec. XX). (Collezione Privata Rossimoda)*

\mathcal{A} shoe that belonged to Pope John XXIII,
worn at the conclave at which he was elected
(1958). (Angelo Roncalli, born at Sotto il Monte,
1881, died at Rome, 1963; Pope 1958–1963.)
(Vigevano Museum)

*Calzatura appartenuta a Papa Giovanni XXIII e
calzata al conclave durante il quale egli fu eletto Papa
(1958). (Angelo Roncalli nato nel 1881 in Sotto il
Monte e morto a Roma nel 1963 — Papa dal 1958 al
1963). (Museo Vigevano)*

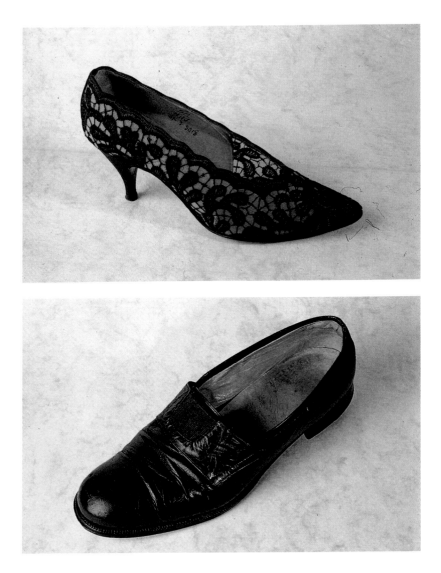

Shoes of Pope John Paul II, donated to the Consortium of Saints Crispin and Crispinian, in Vigevano. (Vigevano Museum)

Calzatura di Papa Giovanni Paolo II, che fu regalata al Consorzio SS. Crispino e Crispiniano di Vigevano. (Museo Vigevano)

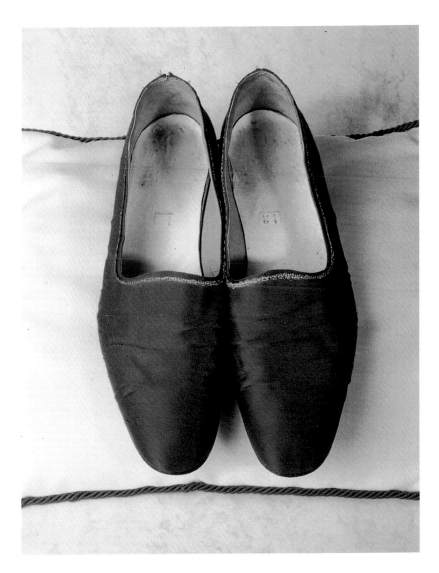

\mathcal{L}ooking at these images in their historical sequence reminds one yet again of what an important role shoes have played in the costume of many civilizations. A book illustrated and documented like this helps bring the history of footwear to a broader reading public, well beyond those of us in the trade. In the past few years there has been an ever-growing interest in footwear as a fundamental element of fashion and of clothing. Shoe design is entrusted to highly skilled specialists and is backed by scientific research. Italian styling has conquered the world's markets, and the mark "Made in Italy" is now synonymous with style and elegance.

This is to the credit of the sensitivity of Italian designers and creative manufacturers, and also of the craftsmanship that has become an integral part of our culture over the ages.

Luigino Rossi

A Bit of History

When we speak of shoes we tend to think of a fashion product, and we very often forget that footwear has served as an expression of historical and cultural phenomena, of custom and of a *modus vivendi*. By studying history we discover that the fashions of today reiterate those of the past, filtered through modern perceptions and updated with technical advances.

But what is important in studying footwear is the connection between product and communication. While history helps us trace the stylistic evolution of shoes through the centuries, it also teaches us that they have always been considered a means of social communication.

The shoe was invented in the endeavor to protect the foot. Depending on climate and terrain, it took the form of sandals, closed shoes, or boots. Some scholars have described shoes as a means of transportation for the body itself, while others propose they were initially a ploy to avoid leaving footprints. But as we delve deeper into the history of footwear, we find that these purely protective functions are augmented by others of a symbolic or ornamental nature, which proclaimed social status or conveyed some less obvious message.

The first suggestion of foot coverings appears in rock paintings from the late Paleolithic era. But the first reliable evidence dates only from 3000 B.C., with the slate cosmetics tablet of Pharaoh Narmer, which depicts the Pharaoh followed by a slave bearing his sandals. In Egypt the sandals worn by the Pharaoh and other dignitaries were a sign of their power; lower strata of society went barefoot.

The type of footwear used in Egypt was the sandal, generally of palm fiber or plaited papyrus, held on the foot by two laces—one around the instep and the other, tied to the first, rising from the front of the sandal and passing between the big toe and the second toe. Sandals took various shapes, each indicating a specific social class. The curved-up toe was reserved for the most powerful.

As time passed and with the development of hide tanning, sandals were made with a leather sole. They were used by the Pharaoh; to symbolize his supremacy over those he vanquished, the inner surfaces of the soles were decorated with images of prisoners (enemies had distinctive representations: Syrians wore a white cloak, Libyans were black figures, Hebrews had long hair and beards).

Around 2300 B.C. the first red dye was discovered (probably by the Phoenicians in Syria), made of the dried bodies of female wingless beetles. But apparently the Babylonians were the first to dye leather in different colors to proclaim the wearer's rank. Red and yellow were reserved for the middle class; pastels were for dignitaries; while the

king and his court wore sandals decorated with gold embroidery and precious stones.

Many references in the Old Testament give footwear a symbolic function.

The use of animal skins in Genesis 3:21: "And the Lord God made for Adam and for his wife garments of skins, and clothed them." Hence shoes are also thought to have been made of animal skins. In Genesis 14:23 Abram, who has defeated five kings and freed their prisoners, is offered a deal by the King of Sodom: He can keep all the goods he has recovered, provided he surrenders the prisoners. Abram answers: "I would not take a thread or a sandal-thong or anything that is yours, lest you should say, 'I have made Abram rich.'"

In Exodus 3:5, God orders Moses to remove his sandals so as not to defile sacred ground; and this custom is still observed by Muslims today as a sign of respect for holy places (the home, mosques, etc.).

Deuteronomy 25:9 says a man must marry his brother's widow; but if he refuses to have her, then she should "go up to him in the presence of the elders, and pull his sandal off his foot, and spit in his face; and she shall answer and say, 'So shall it be done to the man who does not build up his brother's house.' And the name of his house shall be called in Israel, the house of him that had his sandal pulled off."

In the Book of Ruth (4:7) the right of levirate among the Israelites was expressed through shoes: "Now this was the custom in former times in Israel concerning redeeming and exchanging: to confirm a transaction, the one drew off his sandal and gave it to the other, and this was the manner of attesting in Israel." Thus Boaz acquires Mahlon's estate from Naomi—including Ruth, Mahlon's widow.

In Isaiah 3:16–18, feminine luxury is condemned: "Because the daughters of Zion are haughty and walk with outstretched necks, glancing wantonly with their eyes, mincing along as they go, tinkling with their feet; the Lord will smite with a scab the heads of the daughters of Zion, and the Lord will lay bare their secret parts. In that day the Lord will take away the finery of the anklets." In those days women wore ornamental chains on their legs, and wore rings even on their toes; all of which forced them to walk with short, even steps. Even today, Eastern women wear silver and gold bracelets around their ankles.

From Ezekiel 24:15–23 we know that it was customary for those in mourning to go barefoot as a sign of respect for the dead, until God ordered Ezekiel to wear shoes despite his grief.

ANCIENT GREECE

In ancient Greece going barefoot was not synonymous with a lack of dignity, but the Greeks took a great interest in their feet and began to use fitted shoes of carefully chosen materials.

As time went on, a wide variety of footwear developed, notable for its elegance, refinement, extravagance, and rich ornamentation, especially for women. We can find references to this in the poetry of Sappho and Homer. The vast range of Greek footwear falls into three categories: sandals, shoes, and boots. The height of the sole and the color of the ornamentation indicated the wearer's social class. High-soled shoes were reserved for the aristocracy and the rich; wooden sandals were for the poor. The *kothornos* (also known in English as the buskin) and *embates* were particularly used by tragic and comic characters in the theater; the height of the kothornoi symbolized the power of the character being represented, and gods had the tallest soles of all.

There is a legend about the birth of the kothornos: An old man advised husbands to keep their women from going out so much by making their shoes heavier. But the women cleverly foiled their husbands by putting pieces of tree bark under the soles. This was the origin of the wooden-soled sandal, which underwent many developments over the ages, including the Italian chopine of the seventeenth century and the wooden patten of the eighteenth century.

A common model of footwear was the *krepis*, worn by men and women alike—including women of ill repute, who could use them to attract men's attention because these sandals, with their thick, flat sole and heavy leather upper, clacked as the wearer walked.

Footwear of soft white, green, or lemon-yellow leather was particularly worn by courtesans; white sandals were also worn by

betrothed girls and young brides. Boots were reserved for athletes, hunters, and travelers. It is said that the youths of Sparta and soldiers wore red boots to hide the blood flowing from leg wounds, in part because it was bad form to show fear or pain.

Any attempt to curb extravagant footwear, as when Lycurgus (390–329 B.C.) ordered the populace to go barefoot, was doomed to failure, because the greatest visual feature distinguishing free citizens and slaves was precisely in what they wore on their feet.

Footwear was of such importance in Greece that shoemakers evidently specialized in various tasks and products: some cut hides, other assembled the various parts, and there were men's and women's shoemakers.

Florence Ledger, in her book *Put Your Foot Down,* describes the skill of Greek shoemakers, who were esteemed citizens. She tells of an unusual order from a flute player for a pair of "musical" sandals. The craftsman made him thick soles concealing a metal device that emitted sounds under the pressure of his feet as he walked.

The Greeks also made shoes of unconventional materials: The poet Philetas was so thin he is said to have worn shoes of iron to keep the wind from blowing him over and out to sea. Pythagoras, on the other hand, believed that the migratory souls of our ancestors are reincarnated as animals, and so required his disciples to wear only sandals made of tree bark.

Etruscan footwear included a wooden sandal or clog reinforced with thin bronze plates, having nails under the sole for better traction. To protect their feet from the mud when they went out, women in particular wore a very thick wood sandal, often hinged for flexibility with a piece of soft leather nailed with bronze nails to the two halves of the wood sole. The Etruscan sandal was a forerunner of the "Tyrrhenian sandal" of the Roman era and the hinged sandal of the late eighteenth century.

We know the Etruscans were skillful tanners of skins and hides for shoe soles, and their various types of footwear (including high and low boots) had a characteristic curved-up toe.

THE ROMANS

The use of shoes was diffuse in Rome. Eventually their appeal as an ornament outweighed function. The Emperor Aurelian tried to limit excesses, forbidding men to wear colored shoes and allowing only women to choose materials and colors freely. In general, however, shoes carried many meanings: not only symbols of social position, they were also good luck charms, able to invoke the favor of the gods and avert evil.

In A.D. 301 high prices induced the Emperor Diocletian to impose price controls. This law has left us a catalog of footwear in

three categories (*caligae*, *gallicae*, and *babylonicae*) which in turn had twenty-three subtypes. This subdivision, instead of slowing development of more types, in fact accelerated their evolution as a function of use and customs such as different styles for the various times of day.

Anyone but male citizens who were of age (and thus entitled to wear the toga) was forbidden from wearing the *calceus* (shoe or short boot). The color of the calceus indicated social standing: red was at first for the highest magistrates, and later the Emperor's prerogative; black or white for senators; for women, subtler or brighter colors, ornamented with pearls and embroidery.

The *soccus* was worn by comic actors, women, and effeminate men, but gradually came to be considered "unnatural." Soldiers wore *caligae;* when they returned from war with a rich booty, they replaced the bronze nails of their caligae with nails of gold and silver. Legend has it that Gaius Augustus came to be called "Caligula" because he wore these hobnailed boots as a boy.

Claudius Caesar Nero wore silver soles; his wife Poppaea wore golden ones, and even their horses wore golden horseshoes. During Nero's reign, senators suspected of being Christians were stripped of their red boots.

Episodes of black marketeering occurred after the great fire in Nero's reign. Since the government was minting a debased coinage from base metals, the shoemakers closed their workshops, and anyone who needed shoes had to pay dearly for them, under the table, while the rich, who still paid with coins of precious metal, were supplied at night.

For all its magnificence, even Rome had those who could not wear shoes because they were forbidden to: Barefoot slaves could not get far. And the Emperor Vespasian, though himself the son of a shoe-maker, refused to give professional couriers a footwear allowance, in the belief that to run fast, they had to run barefoot.

The poorest people wore only sandals, while criminals wore heavy wooden shoes, to make it difficult for them to escape. Prostitutes wore sandals, while respectable ladies generally covered their feet more fully. Women's feet were such a symbol of chastity that their footwear was worshipped by fetishists: The senator Lucius Vitellus was said to keep his mistress's right shoe under his tunic, and kiss it every so often. Such fetishism led Roman women, as Ovid tells us in his *Ars Amandi*, to confine their feet in tiny shoes, as happened in China where young girls' feet were bound until the bones were deformed, a practice eventually forbidden by law.

The Romans, like the Greeks, never entered a house without removing their shoes, and when invited to banquets they exchanged their shoes for banqueting slippers called *soleae,* carried by a servant or, if he had no servant, by the guest himself, under his arm.

THE MIDDLE AGES

With the fall of the Roman Empire, crafts declined, and shoes became more significant, being among the most coveted of gifts; kings always included a pair with their shipments of gifts to the Pope.

In brusque contrast to the areas and times of Byzantine influence, in which people wore shoes in delicate and varied colors, in the "Dark Ages" in Western Europe shoes were often crude, protection being more important than ornamentation.

Ecclesiastical shoes underwent changes in the Middle Ages. Although at first the purple closed shoe was a sign of churchly dignity and the *solea* was a symbol of humility, between 769 and 814 Charlemagne promulgated the "sovereign's laws" requiring clerics to wear sandals when celebrating Mass.

In the Middle Ages, footwear played a role in many popular rituals that still survive in some areas of Italy and elsewhere in Europe. Among the Lombards, a shoe served to acknowledge a son's legitimacy: The child had to put his foot into his father's shoe, and other relatives then followed suit. In England, one marriage ritual required the guests to try to put on the bride's shoe, but only the groom was supposed to succeed. Such a practice may have been the source for the story of Cinderella.

A father's authority over his daughter was transferred to her husband when her father gave the husband one of her shoes. The groom in turn knocked his bride's head with the shoe, which was then placed at the head of the bed, on his side, during the wedding night.

In the High Middle Ages, fashionable dress revived with a vengeance: This period saw the evolution of the pointed-toed shoe, or *poulaine*. Though it did not catch on as such in Italy, the poulaine flourished in France and England. It may have first

been introduced by Geoffrey Plantagenet (of one of England's royal dynasties), an amateur shoemaker, because his big toe was twice as long as normal.

The language spoken by this type of shoe was purely social, in the sense that the longer the pointed toe, the more important was the person who wore it. Eventually the points (called "pikes") became so long that they were rolled up or supported by a chain around the knees so the wearer would not trip.

In England, pointed toes were regulated as a function of social status. Between 1327 and 1377, during the reign of Edward III, pointed toes were prohibited to all who did not have an income of at least forty pounds a year. And while a prince might wear shoes as long as he liked, pikes could be no more than six inches long for a plain commoner, twelve inches for a landowner, and twenty-four inches for a noble. Some pikes had a bell at the tip. Priests were forbidden from wearing pointed toes. Toward the end of the Plantagenet era, pikes shrank considerably and were stuffed with hair, wool, or moss.

On military shoes, pointed toes were accompanied by spurs at the heels, and the considerable tip-to-tip length that resulted was an aid in staying clear of trap holes.

THE RENAISSANCE

The end of the poulaine was foretold by such episodes as the death of Duke Leopold III of Austria, who died because his long point-

ed shoes impeded him from escaping his assassins. But it was the deformed foot of Charles VIII (who apparently had six toes) that forced him to adopt wide, squared shoes. The Renaissance saw the introduction to fashion of these wide "duckbill" or "ox muzzle" toes. Besides being very comfortable for the toes, these shoes had slashes and cut-outs that let the foot spread and relax.

During this period the so-called "imperfect" shoe was also born: imperfect, because the upper had no heel piece. Later this became the mule or *pantofle*.

With development and economic growth, particularly in the Republic of Venice, there arrived a peculiar type of shoe—the "stilt" shoe or *chopine*. This shoe must have come from the East, since it is almost certain that Turkish women wore tall wooden platform clogs at the baths. In any case, the chopine emerged in Venice and quickly spread to other European countries.

These shoes became so high that when a lady went out she needed a maidservant to help her keep upright. Indeed, the shoes' height was so formidable that laws were passed against such excesses. The Church, on the other hand, approved of chopines, on the reasoning that their height impeded movement (particularly dancing) and thus reduced the opportunities for sin.

This style sometimes led to complications after marriage, when the bridegroom discovered he had married a very short bride. In England, the marriage bond could be annulled if the bride had falsified her height with clogs.

Another type of footwear in use at this time was the patten, a kind of overshoe that was put on before going out, to keep one's shoes clean—since streets were not paved and shoes were often of delicate materials such as cloth, brocade, silk, or embroidered leather.

THE LANGUAGE OF SHOES

During the Renaissance, shoes continued to be as much a sign of social status as a functional object, and a new language of shoes was born.

Jugs and vases in ceramics and other materials bear witness to this language. In the fifteenth century, shoemakers' guilds used shoe-shaped jugs of leather or metal, sometimes even precious metal, in rituals to admit new members. Women's shoes are even said to have been turned into drinking vessels after the wearer's death.

A man who wanted to show his devotion or his desire to marry a lady would give her a jug shaped like a pointed-toed shoe, inscribed "I desire no other." P. Weber reports that in sixteenth-century Faenza one of the masters of the "Bergantini Cup Works" created a majolica-ware "communicating" shoe, inscribed "I think and hope" and "I think and will wait." The inscription is said to express a lover's languishing anticipation.

In the second half of the sixteenth century, the potters of Faenza and Florence created hand-warmers shaped like women's shoes.

A nobleman holding them could not only warm his hands but recall pleasurable memories at the same time.

The language of love and friendship was expressed in India with pointed-toed shoes, which symbolized fertility.

BOOTS

Boots were worn extensively in the late sixteenth and throughout the seventeenth century. They came in a wide variety of styles and lengths, extending even to mid-thigh.

To make the boot fit tightly around the leg, it was soaked in water before it was put on. But when it dried it became so tight it kept the wearer from bending his knees, and horsemen had to walk stiff-legged. This type of boot was very different from those of the Middle Ages, which had funnel-like tops that forced the wearer into a bow-legged gait and proved more than a little troublesome in rainy weather because the water poured right down them.

It is said that when Michelangelo was painting the Sistine Chapel, he wore dog-hide boots that he had to peel away from his skin at the end of the enormous task because he'd had no time to bathe.

Early in the seventeenth century came the introduction of heels, which were well received because of the seductive gait they provoked, particularly in women—so they were not worn merely to make a person seem taller. Women's heels made balance precarious enough that ladies walked with a staff, supposedly for the sake of elegance, but actually a necessity to avoid being sent sprawling or spraining an ankle.

In the age of Louis XIV, the "Sun King" (who reigned from 1643 to 1715), heels became very high, probably because the king himself was so short. They were usually colored red. Apparently the Sun King had his own shoemaker, who was forbidden on pain of death to work for anyone else.

Red heels remained in use until around 1760, though white shoes were preferred during the reign of Louis XV (1715–1774). Men's shoes became low and pointed. In the era of Louis XV a pair of shoes could cost as much as a peasant needed to live for an entire year.

Late in the eighteenth century, heels took on an hourglass shape, and men's shoes were ornamented with buckles. The heel disappeared completely during the French Revolution, while pointed shoes with narrow soles returned.

In the nineteenth century, fashions exemplified Restoration, Second Empire, Romantic, and New Rococo to Art Nouveau tastes. The Belle Epoque saw the return of the heel and the short boot.

Closely buttoned or laced, the boot supported the ankle to reduce risk of sprains.

FOOTWEAR AND EROTICISM

In Chamfort's *Maxims and Considerations*, we read that in the eighteenth century, ladies of the court would tip the manservant to help them take off their boots, so he could find an outlet for his "mischievous ideas" elsewhere.

There have been links between shoes and eroticism in many eras, but the symbolism seems to have intensified after 1800. It is said that Leopold von Sacher-Masoch, from whom we get the word masochism, allowed Mrs. Pistor and Wanda de Dounaieff to whip and walk on him. Rather than objecting, he would actually kiss the shoe that had performed the action.

Freud found an erotic symbolism in footwear, assigning the toe a phallic association.

THE TWENTIETH CENTURY

The First World War brought a shortage of raw materials and a consequent decline in the production of short boots; but they reappeared immediately afterward, in calf or chamois, as did knee boots.

In Italy the thirties and forties were an era of "national self-sufficiency," when the shortage of hides and other raw materials

brought the use of alternatives (fabric, raffia, plastic), with soles usually of cork.

After the war years, footwear once again became an extremely important, refined and seductive element of fashion, and heels again introduced their special body language onto the social scene.

CONTENTS

PHOTO ACKNOWLEDGMENTS

The photographs reproduced here come from the following sources: *Footwear of the Brenta Riviera,* published by Cavallino, Venice, 1979, by kind permission of the Consortium of Master Shoemakers of the Brenta, Stra (Venice), Museum of Footwear, Comm. Benedetto Bertolini, Vigevano (Pavia); and private collections: The Ferragamo Museum, Rossetti Bros., Madras/Valentine Shoe Manufacturers, Rossimoda, Italian Footwear/Italian National Shoe Manufacturers' Association 1979. The photographs of the footwear from the Vigevano and Ferragamo Museums, and from the private collections, were taken by Paolo Liaci for the *Footwear Through the Years* catalogs produced by the Italian National Shoe Manufacturers' Association, the Italian Trade Center London, and the Italian Trade Center Düsseldorf. The photographs from *Footwear of the Brenta Riviera* are reproduced by permission of the Consortium of Master Shoemakers of the Brenta, Stra (Venice). The originals can be found in the following museums: Bally Museum, Schonenwerd; British Museum, London; Correr Museum, Venice.

ACKNOWLEDGMENTS

The publisher wishes to thank the following for their invaluable help:

The author, Eugenia Girotti
The Italian National Shoe Manufacturers' Association (ANCI), Milan
ANCI Servizi S.r.l., Milan
and furthermore:
Mr. Luigino Rossi, Governing Director of Rossimoda Shoe Manufacturers
The Consortium of Master Shoemakers of the Brenta
Mr. F. Piccolotto, President of Calzaturificio Valentine S.p.A. / Madras
Mr. Renzo Rossetti of Rossetti Bros. Shoe Manufacturers
Salvatore Ferragamo S.p.A.
Prof. Paolina Beolchi Rognoni of the Civic Museum of Footwear
Mr. Paolo Liaci and Ms. Marilena Pessina for the photographs
Ms. Gianna Masi, stylist

BIBLIOGRAPHY

Bondi, F., and G. Mariacher. *Footwear of the Brenta Riviera, History and Design* (Cavallino, Venice, 1979).
Bruhn, W., and M. Tilke. *Clothing over the Centuries* (Rome, Mediteranee, 1958).
Descamps, M. A. *Psychology of Fashion* (Editori Riuniti, 1981).
Enciclopedia Treccani. "*La calzatura.*"
Ledger, F. E. *Put Your Foot Down* (Melksham, Colin Venton Ltd., 1985).
Piero Bertolini Museum of Shoemaking. *Cav. Lav. - History and Catalog* (Arti Grafiche Casonato, Vigevano, 1974).
Probert, C. *Shoes in Vogue since 1910* (Condé Nast, 1981).
Sandre, A. *Costume in Art* (Torino, Nova Edizioni d'Arte, 1971).
Swann, J. *Shoes* (General Editor: Dr. Aileen Ribeiro)
Swann, S. *A History of Shoe Fashions* (Northampton Museum and Gallery, 1975).
Weber, P. Shoes, *Three Thousand Years in Pictures* (AT-Verlag, n.d.).
Wilson, E. *A History of Shoe Fashions* (Pitman, 1969).
Yarwood, D. *The Encyclopaedia of World Costume* (Batsford Ltd., 1978).

Bella Cosa